# ENCHANTED *Isles*

## THE SOUTHERN GULF ISLANDS

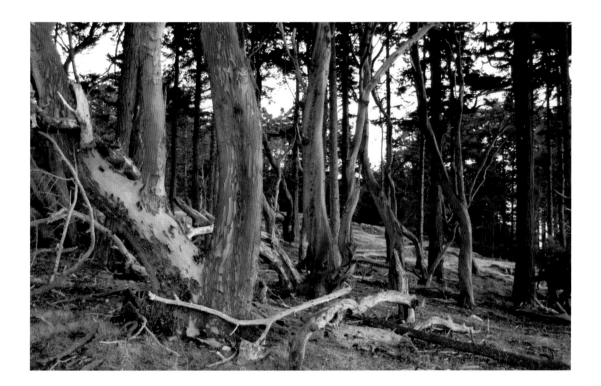

# ENCHANTED *Isles*

## THE SOUTHERN GULF ISLANDS

### DAVID A.E. SPALDING

*photography by* **KEVIN OKE**

# HARBOUR PUBLISHING

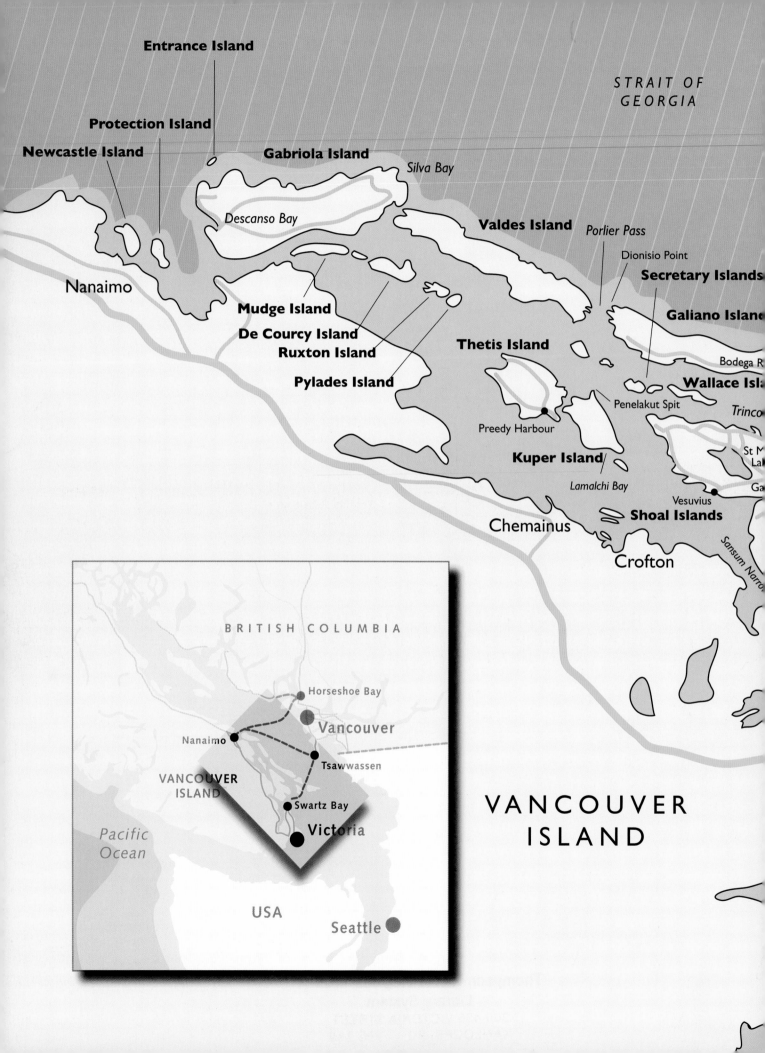

STRAIT OF
GEORGIA

**Entrance Island**

**Protection Island**

**Newcastle Island**

**Gabriola Island**

*Silva Bay*

*Descanso Bay*

**Valdes Island**

*Porlier Pass*

Dionisio Point

**Secretary Islands**

Nanaimo

**Mudge Island**

**De Courcy Island**
**Ruxton Island**

**Thetis Island**

**Galiano Island**

Bodega R

**Wallace Isla**

*Trinco*

**Pylades Island**

Penelakut Spit

Preedy Harbour

St M
Lak

**Kuper Island**

*Lamalchi Bay*

Vesuvius

Ga

**Shoal Islands**

Chemainus

Crofton

*Sansum Narro*

BRITISH COLUMBIA

Horseshoe Bay

Nanaimo

Vancouver

VANCOUVER
ISLAND

Tsawwassen

*Pacific
Ocean*

Swartz Bay

Victoria

USA

VANCOUVER
ISLAND

Seattle

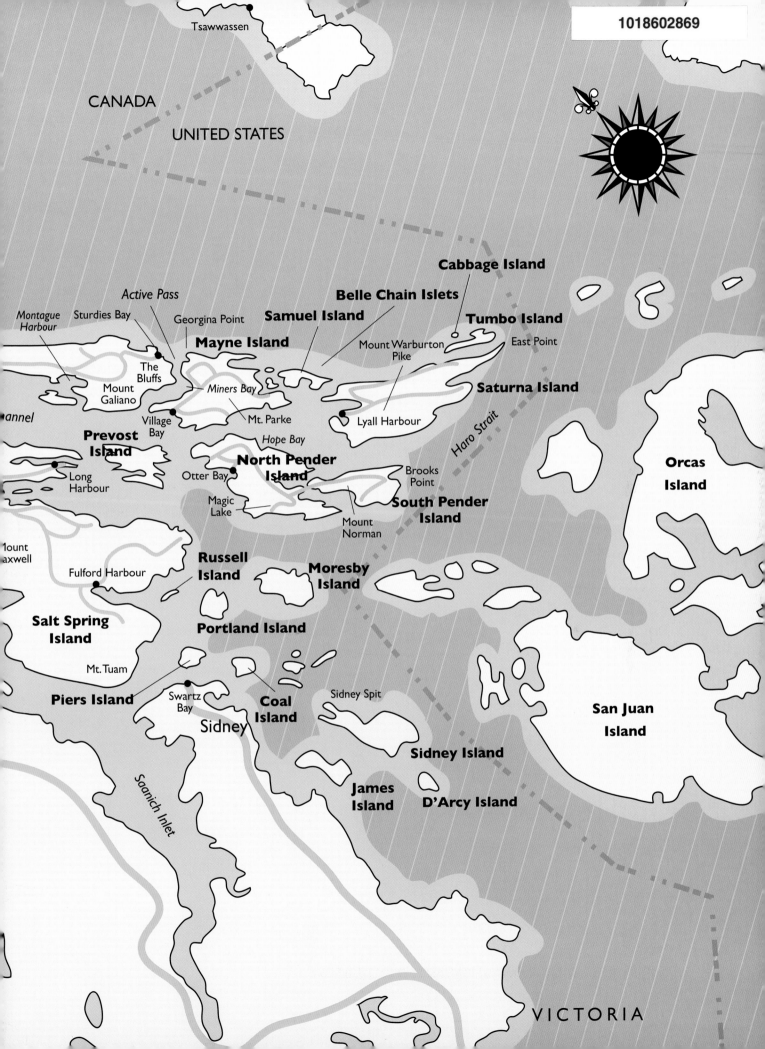

Tsawwassen

CANADA

UNITED STATES

**Cabbage Island**

**Belle Chain Islets**

Active Pass

Montague
Harbour

Sturdies Bay

Georgina Point

**Samuel Island**

**Tumbo Island**

**Mayne Island**

Mount Warburton
Pike

East Point

The Bluffs

Mount
Galiano

*Miners Bay*

**Saturna Island**

annel

Village
Bay

Mt. Parke

Lyall Harbour

Haro Strait

**Prevost
Island**

*Hope Bay*

**Orcas
Island**

Long
Harbour

Otter Bay

**North Pender
Island**

Brooks
Point

Magic
Lake

**South Pender
Island**

1ount
axwell

Mount
Norman

**Russell
Island**

**Moresby
Island**

Fulford Harbour

**Salt Spring
Island**

**Portland Island**

Mt. Tuam

**San Juan
Island**

**Piers Island**

Swartz
Bay

**Coal
Island**

Sidney Spit

Sidney

**Sidney Island**

*Saanich Inlet*

**James
Island**

**D'Arcy Island**

VICTORIA

To Jane, Penny and Lucy
who have all lived on and loved the islands.
– David Spalding

In fond memory of my father, Bev Oke.
– Kevin Oke

# Contents

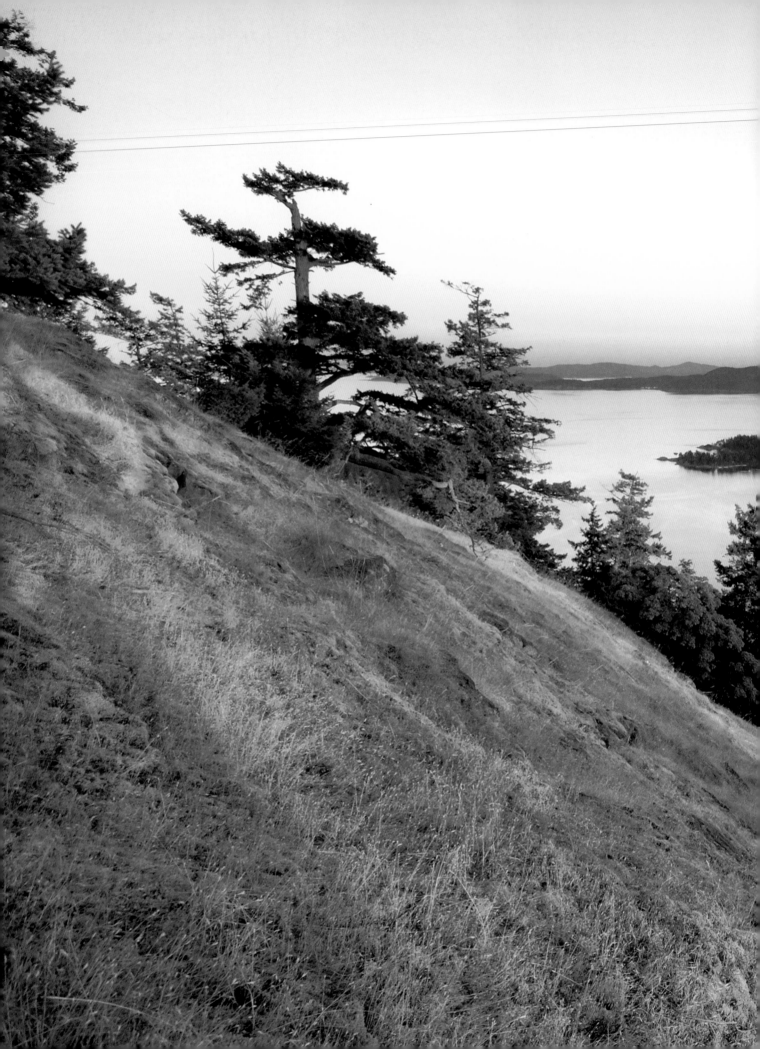

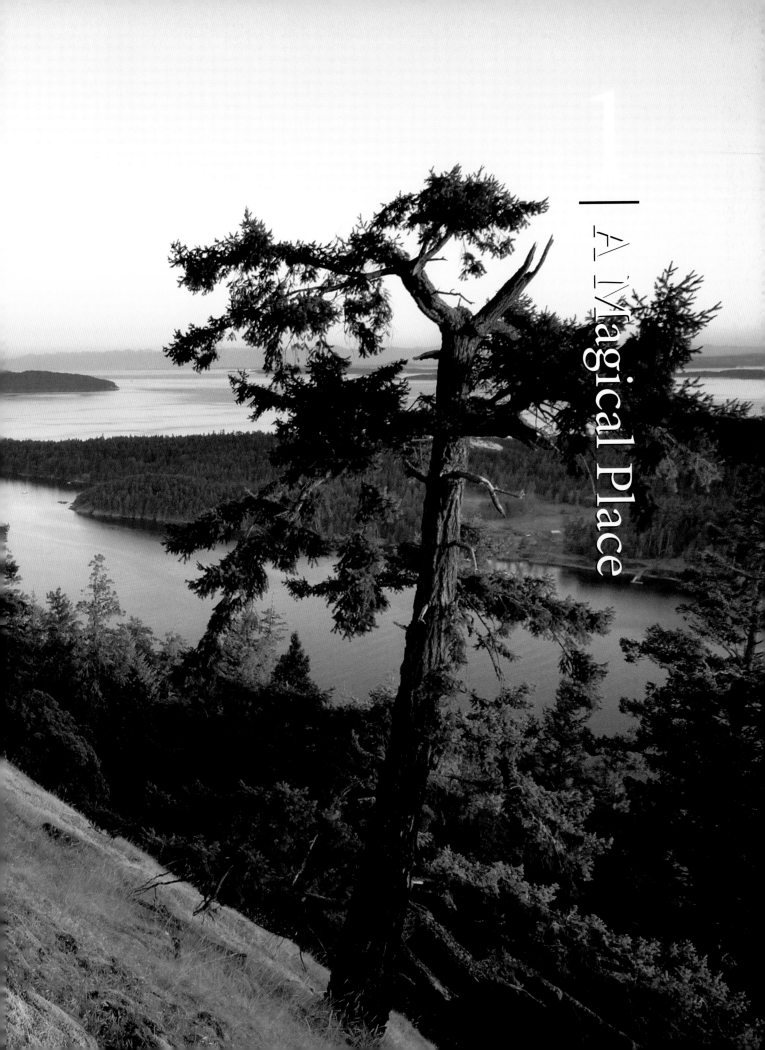

A Magical Place

*Magic happens where land and sea come together. Malaspina Point on Gabriola at sunset.*

**Previous pages:** *Mount Norman is the highest point on South Pender with a panoramic view of the surrounding islands.*

I first saw the Southern Gulf Islands in 1968, as the ferry left Tsawwassen and threaded its way to Sidney. Andrea and I had both tasted delightful islands before in the British Isles, but now we were living far from the ocean in Alberta. We gazed at the opening vistas, the bays and points, the dark velvety forested hills and the brightly painted houses, docks and boats. These seemed enchanted islands, unrelated to anything we'd ever seen. How, we wondered to each other, could one possibly get to live in this magical place? It took us another 22 years to figure it out; we moved to Pender in 1990 and have lived there ever since.

Some are lucky enough to be born on a small island; a few are unfortunate to be sent to one against their will. Some non-islanders are nesomanes, lovers of islands, who visit different ones whenever possible. But most island residents have an experience like ours: a glimpse that begins to work its magic in the subconscious, a dream of a simpler lifestyle, a closer community, nature outside the back door, perhaps an office with a view of the forest or the sea.

At first the dream seems impossible. How could you make a living? asks the voice of sanity. Where would you live? Do you really want to leave all your friends? For those who make the choice, things can suddenly fall into place when a life-changing experience makes familiar patterns seem suddenly less important.

A surprisingly large number of us have taken that step in the last few decades. The hippie generation tuned out and moved back to a simpler life, then post-hippies took over pubs and stores or opened B & Bs. We were in the first wave of telecommuters who found that computers allowed us to carry on a business (in our case as writers) a ferry ride away from our nearest clients. Later baby boomers grabbed their golf clubs and began taking early retirement in droves.

Once you settle on an island, reality kicks in. Life is both simpler and more complicated. The dream job may need to be supplemented for a while; we took contracts off-island, taught playschool, produced gourmet picnics and ran a B & B. Water, garbage and sewage become real issues in a way they rarely are in a city. Nature is indeed just outside the back door, and it's eating our lettuces—and our chickens! And the friends we left behind not only spent the entire summer on our living room couch but booked in themselves and even their friends for next year.

But somehow the dream continued. We did write our books. (Between us, this is our 33rd!) And in ongoing exploration of our own and neighbouring islands, I fell in love with them all over again, this time for their real beauty and history instead of a dimly realized fantasy. It's time to share some favourite discoveries.

## Where's the Gulf?

Ambivalence starts with the name, extent and location of the Gulf Islands. The Gulph of Georgia was the name Captain Vancouver gave in 1792 to the interior sea that we now call the Strait of Georgia. The hydrographer Captain Richards changed Gulf to Strait in 1865, and the name Gulf survives only in the islands. The Gulf Islands lie in or adjacent to the strait, but there is no obvious agreement on their number and extent, and half a dozen recent books on the islands each cover a different range.

This book is about the group generally called the Southern Gulf Islands, which I regard as the archipelago that stretches some 90 kilometres (about 56 miles) from Newcastle in the north to D'Arcy in the south, and east from Musgrave Landing on Salt Spring 40 kilometres

**Above:** *A colourful cornucopia greets visitors to Saturday market in Ganges.*

**Top:** *Boats in the Thieves Bay marina on Pender Island await their skippers' next adventures.*

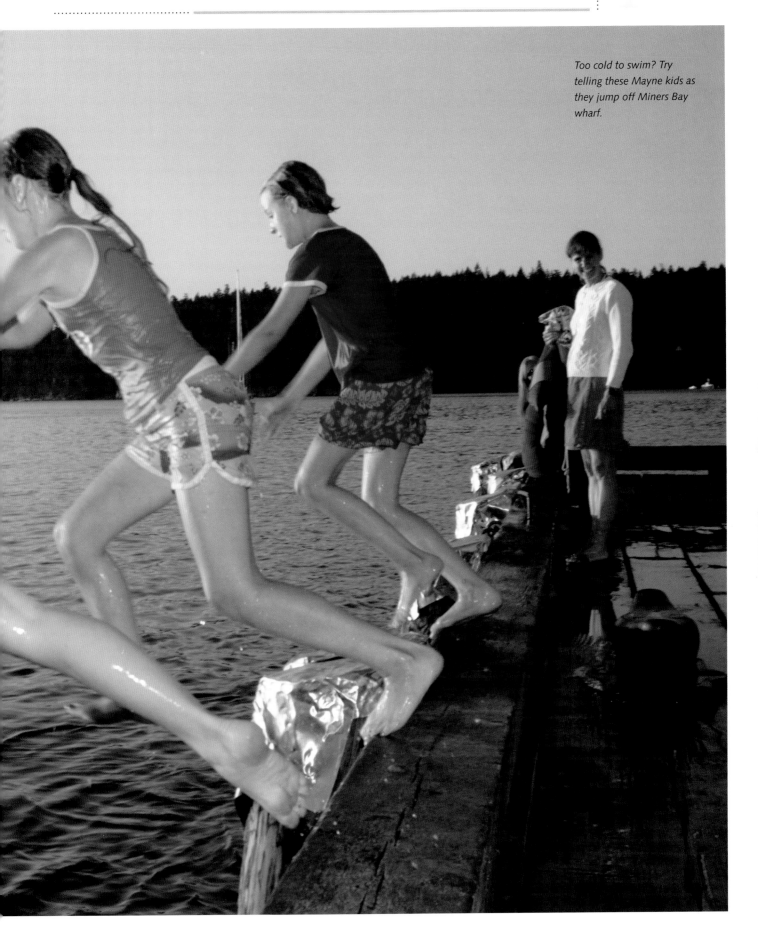

Too cold to swim? Try
telling these Mayne kids as
they jump off Miners Bay
wharf.

(25 miles) to East Point on Saturna. These islands cluster against the eastern shore of southern Vancouver Island; the Strait of Georgia bounds them to the northeast and Haro Strait to the south and east.

The southern islands are conventionally divided into subgroups, even if nobody is quite sure which island belongs in which group. Some or all of the almost continuous series of linear islands from Gabriola to Saturna are generally known as the Outer Islands, a group that usually includes Pender as well. The group of smaller islands south of Salt Spring, from Portland south to D'Arcy, are sometimes regarded as the Inner Islands. Logically then, the remaining islands from Newcastle south through Mudge, Thetis and Kuper are the Middle Islands, of which Salt Spring has a big enough population and presence to stand on its own. Among the main islands are many lesser ones; the larger of these support small farms, residences or seabird colonies, while smaller rocks barely give a seal room to haul out at high tide.

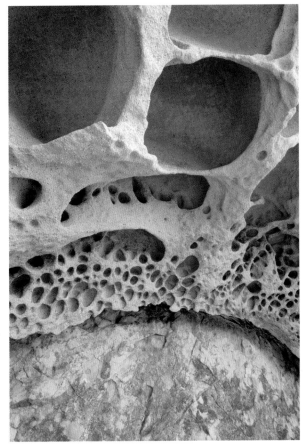

There is a story that legendary logger Paul Bunyan made the Gulf Islands after he dug a harbour for Vancouver; when the city didn't pay, he started to fill it in. Geologists tell us a different story, however. They explain that the Outer Islands and most of the Middle Islands contain Cretaceous rocks of the Nanaimo Group, laid down between 91 and 66 million years ago in an earlier sea. Now steeply dipping sandstones create linear outcrops that shape the long narrow islands and headlands. Older still by 200 million years, the southern half of Salt Spring contains largely Paleozoic sediments and volcanic rocks. All of these rocks and other ancient intrusions are present in the Inner Islands.

A great thickness of ice covered the region during the Pleistocene, but it melted rather rapidly about 14,000 years ago, leaving debris that formed James Island and part of Sidney Island. The sea floor rose as the weight of ice decreased, but the melted ice also raised the sea level so that raised beaches formed at various levels on the islands. The present shorelines stabilized about 5,000 years ago.

**Above:** *Sandstone weathered in fanciful honeycomb patterns at Narvaez Bay.*

**Opposite:** *The sea creates and surrounds the islands, and provides an ever changing spectacle.*

Nestling in the rain shadow of Vancouver Island, the Southern Gulf Islands have a cool Mediterranean climate with the highest average temperatures in the country. Victoria International Airport is the nearest official station, supplemented by a network of privately run observatories on the islands. Rainfall of around 36 centimetres (14 inches) barely supports the water table, and the sun shines more than 2,000 hours a year. The warm fall may be wet and foggy; the rainy, cool winter (mean 5–10°C, or 41–50°F), sometimes brings snow to higher ground for a few days. Flowers bloom early—I often see the first snowdrops on our Christmas bird count—and spring has the most windstorms, often leading to power outages as trees fall on the lines. Summer is warm (mean in the low 20s°C, or low 70s°F) and dry with long sunny days.

The islands fall within the Georgia Depression Ecoprovince, where a dry sunny climate supports forest vegetation dominated by coastal Douglas fir. The islands have fewer animal species than surrounding landscapes; squirrels have never made it to some islands, for example, and humans have exterminated the largest deer (elk) and predators. Prominent land mammals include black-tailed deer; orcas, seals and sea lions inhabit adjacent marine

*Harbour seals haul out on undisturbed islets.*

areas. River otters, raccoons and mink use both the water and the shores. A great diversity of birds lives here, more than anywhere else in British Columbia. The region includes island nesting colonies of several marine species and important feeding grounds for wintering water birds.

Gulf Islands archeology gives us a picture of the past 5,000 years, but a Washington state mastodon with a stone point embedded in a rib suggests First Nations have lived in the region for at least 12,000 years. Discovery by outsiders to British Columbia went undocumented until the late 18th century, when fur traders pushed west overland and Russian, Spanish, British and American sailors explored the coast. Outside recognition of the Gulf Islands did not come until the early 19th century, and settlement began a few decades later.

"In the early days," remembered Mrs. Fred Smith of Pender Island, "it was easier to get to the islands by boat than it was overland to any place in British Columbia, so that's why people came here."

The Southern Gulf Islands, along with several other islands in the region, fall under the administrative mandate of the Islands Trust. Some islands also form part of a regional district (Capital, Cowichan or Nanaimo Regional District) that has responsibility for transportation and utilities. The Gulf Islands National Park Reserve includes some small islands and parts of larger islands. Immediately across the border in the United States, the San Juan Islands are similar in many ways to our Gulf Islands, and their authorities have ongoing discussions on issues of common interest with the Islands Trust.

Close to centres of population, the islands were fairly accessible to early settlers. Year-round island populations are still relatively small—under 19,000 in the 2006 census, the source of all island population figures in this book—but with the modern ferry service, a flurry of float planes and flotillas of private craft, the islands are even more accessible to major population centres and receive many thousands of visitors, particularly in summer.

*A sea of daffodils announces spring at Miners Bay, Mayne Island.*

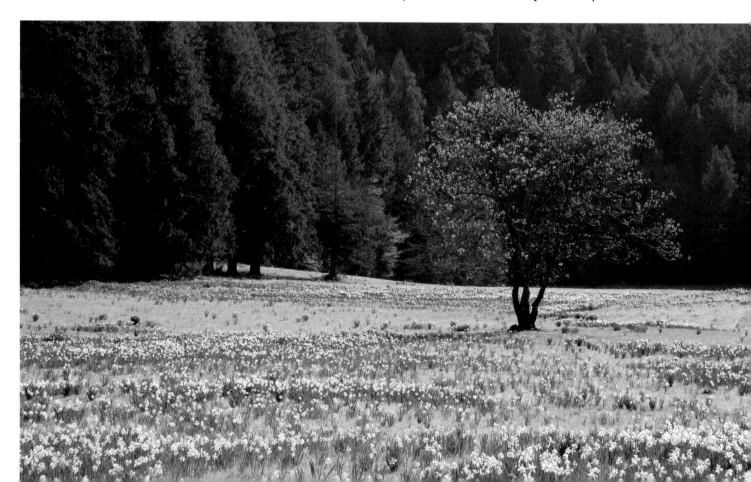

A half-hour ferry ride links the islands to the Greater Victoria, Cowichan and Nanaimo districts of Vancouver Island, with some half a million people. A roughly hour-and-a-half ride connects the islands to Vancouver and the Lower Mainland, with another couple of million residents. A short flight or two ferry trips away, Seattle and its environs house another four million. This totals more than six million people living within a couple of hours' journey. Accessibility is part of island charm, but it is also the source of many island problems.

## Ferry Tales

An island is a piece of land completely surrounded by ferries, goes the islanders' story, and they're all running late! While not entirely fair, Gulf Islanders do have fewer illusions about the ferry system than most users. For islanders the sea is both a barrier and a highway, and means of crossing it are vital.

Some islanders have their own boats, which are indeed almost a necessity for those on islands not served by BC Ferries. School-aged kids from the Outer Islands nonchalantly head to Salt Spring's high school by water taxi, on the way finishing homework or catching up on sleep or gossip. High flyers on the islands and upscale visitors to larger resorts trip to and from Vancouver or Seattle by float plane, but most of us take these only on special occasions. Regular folks take ferries, which thus play a disproportionately important role in island life.

Originally people travelled among the islands in long-distance vessels or a variety of local craft powered by paddles, oars, sails or small motors. In 1883 the Canadian Pacific Navigation Company bought some of the vessels, and the Canadian Pacific Railway purchased the company in 1901. Car ferries began running in 1923, starting another era of fragmented service. It was not until 1961 that the provincial government cobbled together elements of these services into the BC Ferry Corporation, variously known as the Dogwood Fleet from its emblem or Bennett's Navy after the colourful premier who created the system. Most recently the government has privatized the system, and islanders watch ongoing changes in safety, cost and service with mixed emotions as usual.

The system provides more than transportation, as its vessels and terminals offer a primary meeting place for many islanders to exchange news and transact island business. And of course the vagaries of service provide a vital subject of gossip and discussion, along with the doings of deer, tourists and other islanders.

*Saturna offers a one-day "water taxi" service to marine arrivals for the annual Lamb Barbecue.*

## Budding Hermits

"I'm a recluse," wrote South Pender Islander Arthur Spalding in 1888, "As certain people term it, / In other words, a sort of budding hermit."

In the rest of his entertaining verse, Arthur describes how on his "lone island" he shuns "the sons of men, still more their daughters," describes his "modest duties" on the farm, and rejoices that his clothing includes "no starchy cuffs, no stick-up collars I, / No studs to fasten, no confounded tie."

*The* Howe Sound Queen *arrives at Vesuvius on Salt Spring from Crofton (with its smoky pulp mill) on Vancouver Island.*

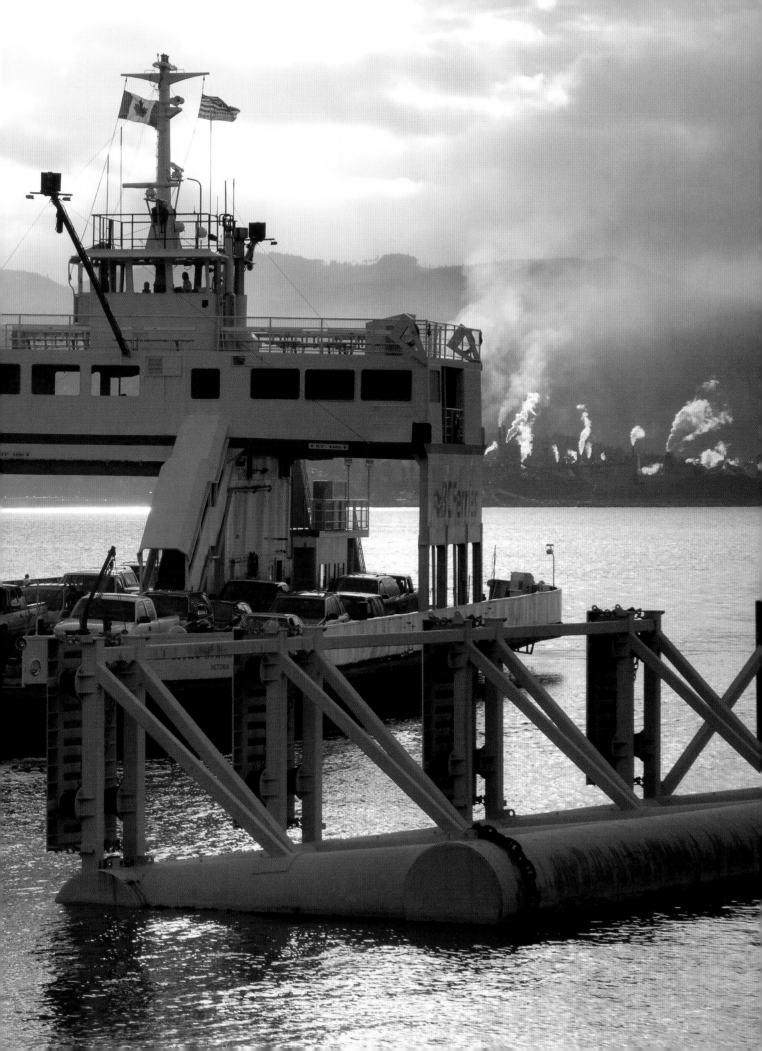

*A Mudge Island car flaunts convention with a home-made licence plate.*

To avoid confusion, I should add that when I talk about Arthur and his family, I am not boasting about my relatives. Arthur Spalding was a Pender resident nearly a century before my arrival in the islands, and as far as his descendants and I can calculate, we are not related in any way.

Arthur was a pioneer in many ways, not least by helping to create the Gulf Islanders' reputation for eccentricity and originality. Initially the islanders reacted against the extreme conventions of England's Victorian society, but they have continued to swim against the tides ever since.

Remittance men and other escapees from British stuffiness form one stream of islanders, but there have been many others. A list of Salt Spring people in 1895 included a Patagonian, and in those early days the islands were also home to Germans and Portuguese, Hawaiians and Americans, Shetlanders and Scandinavians. Today, although some islands are less racially varied than the nearest city, you may find people from virtually anywhere in the world.

The originality shows up in the variety of ways of earning a living. The islands have of course supported farmers, fishermen and a wide range of small commercial service- and tourist-oriented businesses. But islanders have also been artists, biologists, broadcasters, chefs, cougar hunters, explorers, filmmakers, hoteliers, inventors, lawyers, musicians, naturalists, photographers, poets, premiers, printers, professors, prophets, sailors, sculptors, sealers, senators, whalers and writers.

A lot of "names" well known to the news and gossip columns live at least part-time on the islands. You may rub shoulders with some in the grocery store, while others hide out away from the paparazzi. A handful of well-known past and present islanders include artist Robert Bateman; broadcaster Arthur Black; former premier Mike Harcourt; musicians

*All-or-nothing dress styles on view c.1900 at Malaspina Gallery, Gabriola Island.* British Columbia Archives, H-05307

Bob Bossin, David Essig, Lester Quitzau and Mae Moore, Raffi and Valdy; novelists Bill Deverell and Jane Rule; and senator Pat Carney. Real and rumoured visitors include half of Hollywood.

Island time—a relaxed approach to life that may bring contractors not only an hour or so late but on the wrong day—is one of the few experiences common to all the islands. Each island has its own history, initially shaped by the personalities of the first prominent settlers, who in turn encouraged other settlers of like ethnicity, class or philosophy. Thus each island has its own style, coloured partly by geography and history but mostly by the mix of settlers that shaped its personality.

Accordingly, you will find the flavour of each island presented as separately as possible in the following chapters; some stories reflect more than one island but of necessity appear in only one place. The final chapter guides visitors and residents to fuller enjoyment, celebrates the creativity of our communities and discusses some challenges and changes on the islands in recent years.

**Above:** *Salt Spring's market is a good place to find some of the island's fine handmade crafts.*

**Left:** *Saturna Island from Hope Bay on North Pender Island.*

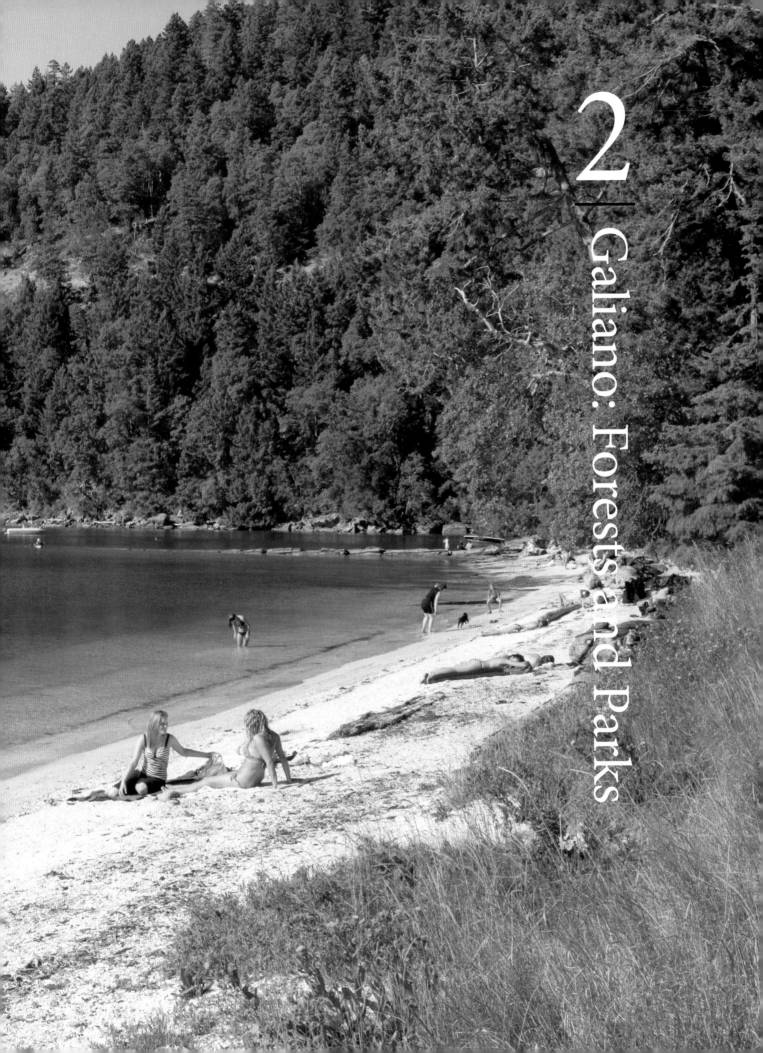

2 | Galiano: Forests and Parks

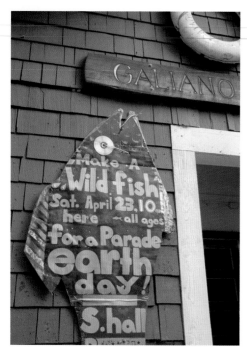

Earth Day is an important event at Galiano's community hall.

On a June morning in 1996, leading a party of naturalists from Britain, I sailed out of Montague Harbour on Tom Hennessy's lovely catamaran the *Great White Cloud*. We expected the sail to be a highlight of our visit to the islands, but as we left the harbour a cold wind and dark clouds blew up. Within minutes heavy hail pelted the group and turned the deck white. Soaked and shivering in summer clothing, we had to turn back, regroup and reschedule the trip. I've sailed with Tom a number of times before and since that occasion and never had a similar experience, but it's been a perpetual reminder that the islands can throw in a surprise when we least expect it. During the research for this book, Galiano produced several more surprises. One day as I looked down from the bluffs I saw, instead of the usual passing ferry, the four-masted Japanese sailing ship the *Nippon Maru*. A few days later, one of the most serious fires recorded in the Gulf Islands hit Galiano.

Montague Harbour, a quarter of the way up the southwest side in the shelter of Mount Sutil to the south, is one of the best harbours in the islands. Parker Island shelters the west, and Gray Peninsula in Montague Marine Park the north. Tom and his wife, Ann, set up their base on the east shore in an early tourist resort, the historic Sutil Lodge.

Galiano is 26 kilometres (about 16 miles) long, a maximum of 6.5 kilometres (four miles) wide and approximately 58 square kilometres (22.4 square miles) in area. Its shape on the map and in profile is something like a rib, with the long narrow blade curving northwest and the knobbly part to the southeast. On the map Montague Harbour takes a big bite out of Galiano, almost separating the island into two parts. To the northwest of Montague, the long narrow island has a sparser population. At the north end, for some years only boaters have had access from Porlier Pass to the Dionisio Point Park. Also well up the island, a fine

Sandstone formations at Sturdies Bay, a common sight on the islands.

**Previous pages:** *The white sand beaches at Montague Harbour Marine Park are some of the best in the southern Gulf Islands.*

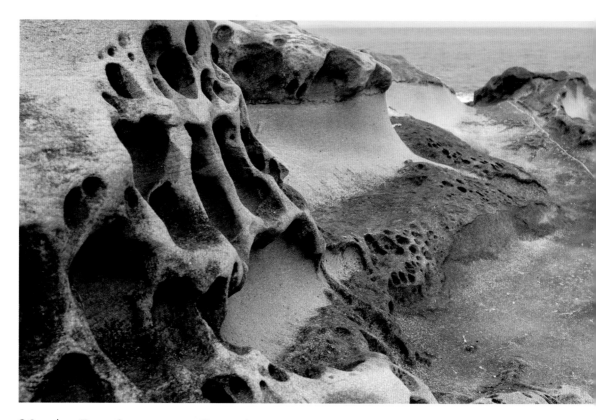

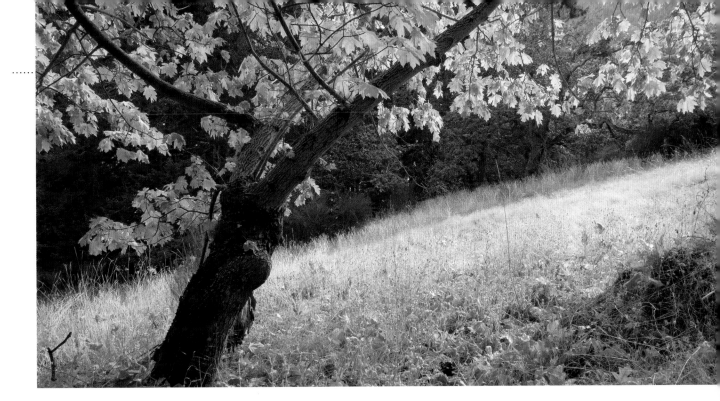

*Bigleaf maples provide fall colours in Bluffs Park.*

trail follows the heights of Bodega Ridge. The north of the island is still mostly forested, which reflects its history as a tree farm and gives rise to ongoing controversies about the extent and nature of development acceptable on the forest lands.

The outer ridge forms the northeastern high ground. Another broken ridge begins with the twin mountains—Galiano, the island's highest point at 341 metres (1,119 feet), and Sutil—that overlook Trincomali Channel and the serpentine Active Pass. The ridge falls at Georgeson Bay and rises again to Bluffs Park and Matthews Point Park. Bellhouse Park is a pretty spot giving a fine overview of Sturdies Bay, where the Gulf Islands ferry makes its first stop from Tsawwassen. This makes Galiano particularly attractive to people with Vancouver connections. Most of the 1,258 people and necessary services cluster within reach of the ferry.

A favourite trail of islanders and visitors alike runs along the ridge in Bluffs Park. There, with your back to the forest, you can look 120 metres (about 400 feet) down the rocky slope to get an eagle-eye view of the great superferries cruising narrow Active Pass. On the far side of the pass, Mayne Island occupies the foreground, and beyond you can scan a great range of Canadian and American islands stretching southward to the Coast Mountains, the Olympic Peninsula and the Cascade Mountains.

Much less often observed is a geological story revealed higher on the path. There you stand on a ridge of the Geoffrey Formation, made up of a conglomerate of pebbles embedded in a sandy matrix. They were laid down some 70 million years ago in a sea not too different from the present Strait of Georgia, bordering an older continent, and afterward raised and folded into their present position. They eroded to roughly their present shape until a mere couple of million years ago, when a great sheet of ice flowed from the Fraser River valley, across the strait and up and over the hill. Stones frozen in its base acted as a giant rasp, grinding the pebbles down into a smooth flat surface that is still visible on parts of the path.

## *Captain Dionisio Galiano*

Galiano Island is one of the four Outer Islands that bears a Spanish name. Until the late 18th century, the Spanish colonies of Mexico and California sent a number of expeditions

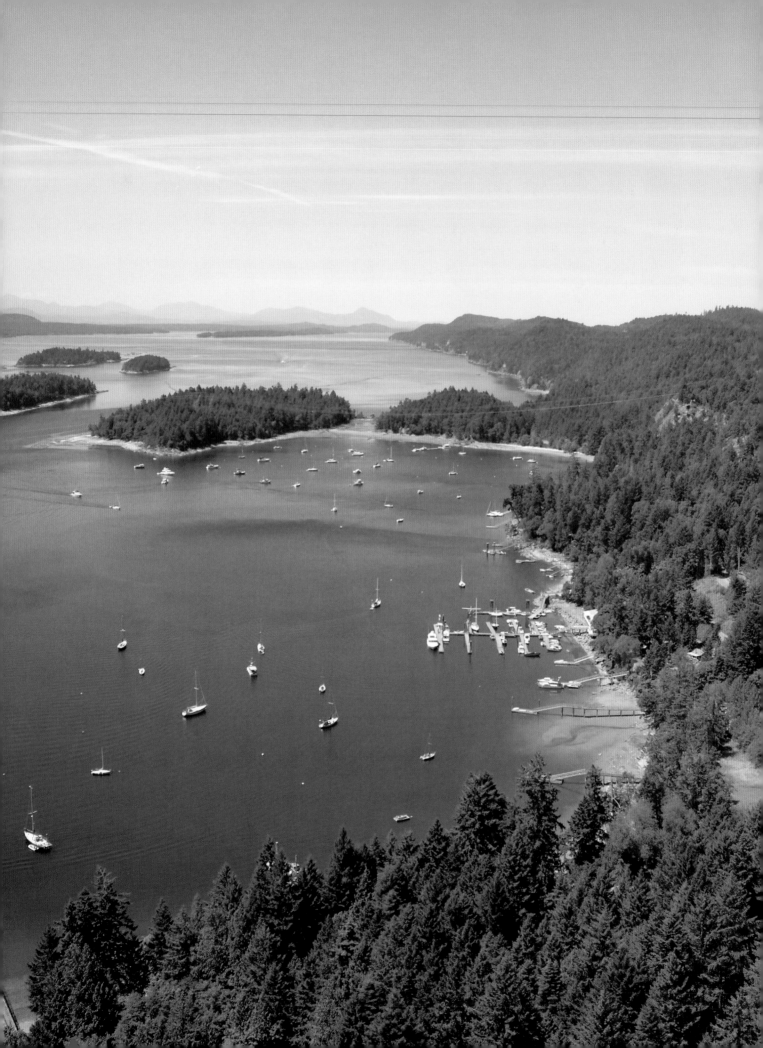

north as far as Alaska. Spanish sailors were the first Europeans to contact West Coast First Nations in what is now British Columbia, and the first to enter the protected passage east of Vancouver Island. Captains Dionisio Alcalá-Galiano of the *Sutil* and Cayetano Valdés of the *Mexicana* entered the strait in 1792 seeking a western entrance to the fabled Northwest Passage. They anchored in a bay off Galiano.

Unknown to the Spanish captains, the English Captain George Vancouver had carefully surveyed the south shore of Juan de Fuca Strait and worked north along the east shore into what he later called the Gulf of Georgia. Trying to avoid the shoals off the Fraser River, on June 13 Vancouver landed on what must have been a Southern Gulf Island. Almost a century later at Georgina Point on Mayne, settler W.T. Collinson reportedly found a knife and a 1784 English penny, which have credibly been hailed as evidence of Vancouver's presence.

Returning south on June 22, the Vancouver expedition encountered the Spanish ships near Point Grey. They met amicably, shared data and headed north together. They proved the Gulf of Georgia was not really a gulf by sailing right around Vancouver Island to Nootka. Vancouver courteously named a couple of islands off the north coast (since renamed) after captains Galiano and Valdés.

The first map after these expeditions to show the Gulf Islands in any detail dates from 1795. Juan Pantoja and José María Narváez drew on material from Captains Galiano and Valdés to prepare the map, which shows what seem to be unnamed approximations of Salt Spring and Pender and an "I(sl)a de Saturna" that could be an undifferentiated Galiano, Mayne, Samuel and Saturna. The gulf coast lies unbroken northward to a cape named Punta de Gabiola, which must be modern Gabriola.

Vancouver and Baker's 1801 map is quite similar, showing roughly the same outline but no names. Vancouver may have seen the Spanish map but died in 1798 before the publication of his own travels. In view of their friendly relations, it is ironic that both Galiano (commanding a ship) and Valdés died fighting the English in the 1805 Battle of Trafalgar.

**Above:** *Fun in the sun at Montague Marine Park.*

**Opposite:** *Montague Harbour attracts recreational boaters to BC's first marine park.*

### Flattering the Admiral

Our names for the islands generally date from 19th-century British Navy surveys. Some islands' names honour or were used by Spanish surveyors, but most other names of islands, peaks, points and bays refer to senior officers, colleagues and ships.

For the previous several thousand years, First Nations lived on the islands and used their own names; Mount Tuam on Salt Spring is one of few surviving on modern maps. Their descriptive names for the islands are gradually coming back into use in the wider community. Cowichan, Penelakut, Snuneymuxw and the Saanich Peninsula people speak different dialects of Coast Salish and may use different names for the same islands.

The Penelakut name for Galiano was *Swikw*. The Saanich peoples called North Pender *S,dayes* (wind drying), which refers to preservation of salmon, and called Saturna *Tekteksen* (long nose) for its prominent East Point.

## *Jamming with the Burrill Brothers*

The freshly caught salmon lay stretched out on the counter between two men in the Galiano store.

"What do you want for it?" asked storekeeper Joe Burrill.

"Two cans of salmon," answered the local Native who had brought it in.

Stories like these were swapped around the stove in the Burrill brothers' store for nearly half a century, and some hearers at least recognized the clever strategy of the fisherman who could not easily preserve his surplus catch.

The Burrills were not the first settlers on Galiano. Henry Georgeson from the Shetland Islands arrived in 1863 and settled in the bay now named for him. John O'Brien, Henry Morris, Harry Clapham and John Shaw, among other early arrivals, created a small community where the Burrills saw a business opportunity.

Joseph Burrill grew up in a vicarage near Richmond, Yorkshire, and by 1896 had acquired 32.4 hectares (80 acres) of Active Pass waterfront on Galiano. Three years later his older brother Fred arrived. They farmed together for four years, then recognized that their neighbours had to cross to Mayne Island for supplies and opened their first store in 1903. In 1906 they constructed a newer and bigger building.

The shy brother Fred ran the farm, cooked and made furniture, while outgoing Joe took charge of the store. He hung a Swiss cowbell over the door so that his customers could let him know they were ready to buy when he was busy elsewhere. The Burrills delivered large orders around the south end of the island, first by ox cart and later by horse and buggy. In due course the store housed the post office and the island's only telephone, and Joe later added a library and gas pumps. The lifelong bachelors loved children and always gave them candy when they came to the store.

The brothers also introduced many children to music and would join musicians in the Georgeson family to play for community dances. Joe played piano, guitar, banjo and violin at home and while visiting neighbours. Islanders remembered Joe's comic and sentimental songs, but he also played classical music, and in true Yorkshire fashion, when he had time would hammer his way through a piano version of Handel's *Messiah*.

The Burrill brothers sold their store in 1947, and new owners moved the building and added a false front. A century later it still serves as a coffee shop where people enjoy island stories and live music.

*The Burrill Brother's store has served as a community centre for over a century.*

## Montague Marine

A far earlier place for Galiano gossip was long known as *Kwi'kwens,* the Saanich name for what is now known as Montague Harbour Marine Park. It contains six white-shell middens built up by three thousand years of First Nations settlements. As the tides erode the bank, shells break down to produce today's beautiful white beaches; erosion and excavation have also revealed spearheads, arrowheads and stone carvings. A rise in sea level may have flooded even earlier living sites; for a while these drew a group of archeologists who grubbed on the sea floor, earning the nickname Montague Mudsuckers.

The area attracted later settlers such as Captain Gray, who planted an orchard in the 1890s on what is now known as the Gray Peninsula. The sheltered harbour attracted other settlers and for a while housed Galiano's old ferry dock. Still in occasional operation in stormy weather when I first came to the islands, it was demolished in 1998.

Many recreational sailors use the sheltered bay, and in 1959 the area became British Columbia's first marine park. On summer weekends the bay fills with boats, campsites are full and around mealtimes the "pub bus" shuttles campers and boaters to and from the nearby Hummingbird Pub. As well as middens and beaches, the 87-hectare (215-acre) park contains forest, lagoons and tidal salt marsh. Over 130 species of birds have been recorded in the park, and an unusual colony of double-crested cormorants once inhabited juniper trees on the nearby Ballingall Islets. The colony survived harassment by eagles and the trees' death under a rain of droppings, but predation seriously decreased the population in 1984. Now the colony has moved to nearby cliffs on Galiano.

Building on success, the province has developed a network of marine parks. The many parks created in the 1960s in the Southern Gulf Islands include Newcastle Island, Sidney Spit, Beaumont (Pender), D'Arcy Island, Princess Margaret (Portland) and Pirates Cove (De Courcy); in the 1970s, Isle-de-Lis (Rum), Cabbage Island and Winter Cove (Saturna); and in the 1980s, Whaleboat Island (De Courcy). The Gulf Islands National Park Reserve has since absorbed some of these parks.

## *Saving the Trees*

"What's that strange tree?" ask visitors from the east.

The arbutus, known as madrona south of the border, is the most striking tree of the islands. The bark on its twisted trunks and branches begins as a clear green, gradually turns red and then grows coarse scales that eventually peel off, starting the cycle over again. Some of its big, oval, shiny dark green leaves stay on year-round, but others fall through the year, so that the tree is always green yet often surrounded by a circle of dead leaves. Most striking are the waxy white bell flowers—which show the tree to be a giant heather—and the bright orange berries that follow. Knowing would-be islanders look for land with arbutus trees, not only to enjoy their beauty but because they know it grows best on sunny spots.

Other characteristic trees of island forests include the red cedar, bigleaf maple, Douglas fir and grand fir, and some western hemlock, Pacific yew and dogwood. Garry oak often grows in well-drained areas such as the top of Mounts Galiano and Sutil, and shore pine and juniper sometimes grow in exposed areas near the coast. Red alder is the first tree to invade open areas.

*Montague Harbour Marina, a popular boating destination.*

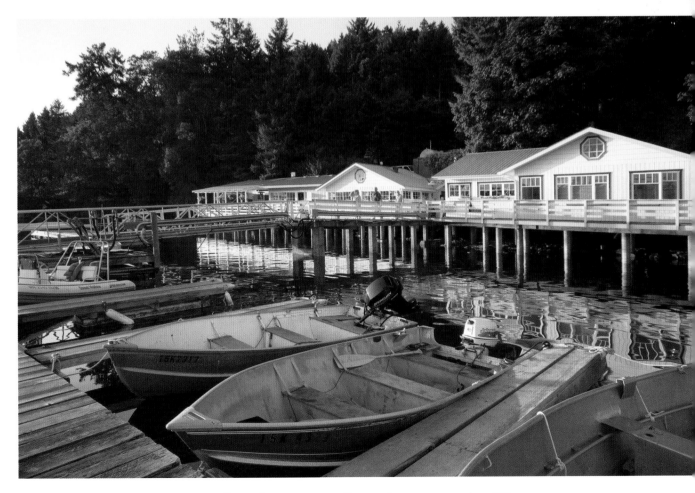

While some forested areas may seem pretty wild to an urban visitor, don't mistake the Gulf Islands forests for old-growth wilderness. Almost everywhere you'll find stumps of much bigger trees in the dark shadows, often showing chopped rectangular holes where loggers inserted their springboards and stood on them to saw through the trunks. Settlers began logging as soon as they arrived and stripped the best timber from almost every area of the islands by the middle of the 20th century. They often burned slash, so generally only a few big Douglas firs, too misshapen or far from the water to be worth cutting, survive the destruction.

Galiano Island pioneered forest protection in the islands. Max Enke, born in Manchester, England, brought 13 Belgian farm workers to Galiano in 1907. He purchased several properties and eventually owned 526 hectares (1,300 acres). His wife, Marion, came from a wealthy Montreal family and had studied English Literature at Cambridge. Their daughter, Ruth, was the first white child born on the island. In 1947 the Enkes sold 15.4 hectares (38 acres) and gave another 37.2 hectares (92 acres) to the Galiano Island Development Association. Much of the money was raised by donation at concerts presented by Paul Scoones, a former mathematics master at Eton. He played selections from his classical record collection "every evening of every summer through the '30s and '40s." The Galiano Club, which Paul helped to organize, held title to the land and opened Bluffs Park in 1948. Ironically, in the light of later controversies, part of it was logged to provide revenue for park improvements and the community.

A further substantial part of Galiano Island survived as forest for many years, after MacMillan Bloedel purchased more than 60 percent in 1951 and used it as a tree farm. Harvesting eventually removed the forest, however; in burned-over clear-cuts, tree planters replace the trees with seedling Douglas fir. An uneasy peace continued until the 1970s, when complaints about the extent of logging, and development on other islands, led to major controversy.

## *Fire in the Forest*

Until I moved to the Gulf Islands, I had never lived in a forest. Every time there is a windstorm, trees shed—arbutus leaves, cedar twigs, Douglas fir branches— and sometimes a whole tree that was insecurely rooted falls across our drive on Pender Island. I pick up debris that falls near the house and saw fallen trunks into firewood, but in the undisturbed forest around us this debris accumulates on the ground between the trees, slowly decaying at the bottom but receiving fresh loads with each new storm. In winter this stuff gets pretty wet, but in summer it becomes tinder dry.

In wild woodland, sooner or later a lightning strike in the debris will start a forest fire, sweeping through a tract of country and starting the ecological cycle again from bare ground. First Nations used fire to keep open the oak meadows where they harvested camas bulbs. The development of commercial forestry made fire an enemy to be stopped at all costs. We can ban campfires and try to teach smokers to be careful, but whatever we do, lighting strikes. Each summer Gulf Islands residents sniff the breeze and watch anxiously for smoke. Volunteer fire crews serve each of the larger islands, and they rarely lack opportunities to test their skills. But most of all, everyone dreads fire in a wooded housing development.

The most serious fire on the Southern Gulf Islands was first reported on Sunday, July 23, 2006. It started in an abandoned gravel pit and spread on the east side of Galiano. It came close to BC Hydro transmission lines, increasing the potential

**Below:** *Ancient stumps date back to a time when trees were big and loggers felled them by hand.*

**Bottom:** *Five weeks after Galiano's biggest fire a fern promises new growth.*

The arbutus tree with its
peeling bark is an island
icon.

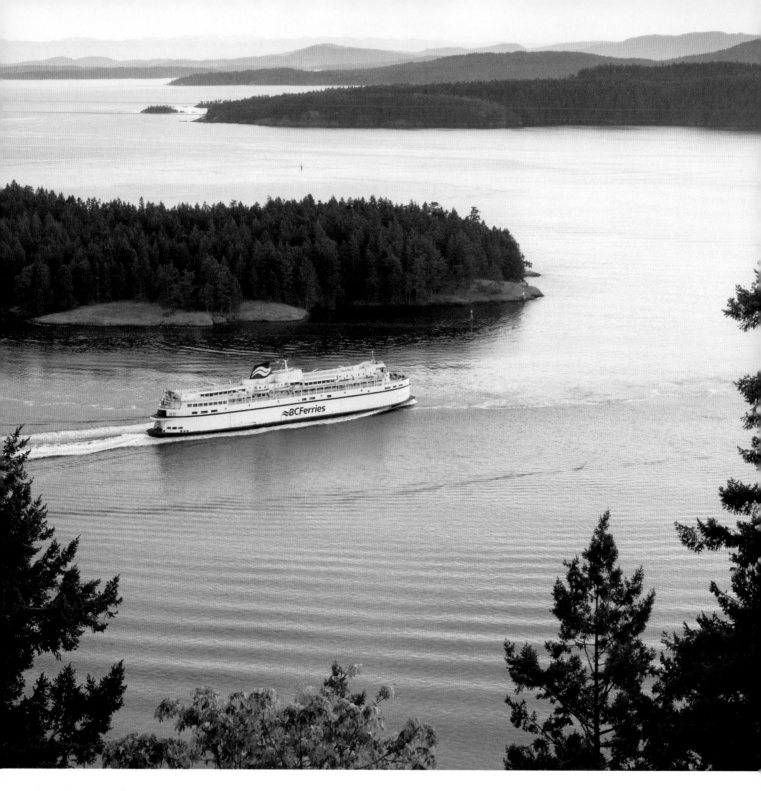

*Active Pass carries the heaviest traffic in the Southern Gulf Islands; here a ferry prepares to round Helen Point on its way to Swartz Bay.*

impact of the fire to a Vancouver Island blackout. By the next day the fire had spread to 61 hectares (151 acres), "candling trees 80 to 100 feet high" (about 24 to 30 metres), and the province had declared a state of emergency. Two hundred firefighters were on the job, including the island's two fire crews, forest service crews and teams from other islands. Three water bombers and four helicopters were deployed. The fire burned to within 200 metres (about 650 feet) of two homes, which firemen kept hosed down. During the night 120 residents and visitors were evacuated from their homes and billeted in other homes, restaurants and the Lions Hall. The ferries turned away visitors and allowed only firefighters, residents and media to land. Evacuated residents were allowed back in their homes Wednesday, July 26.

This was a serious fire, even though there was no injury or loss of buildings. A similarly sized fire in a more populated district would be a major crisis. A 61-hectare (150-acre) fire in Magic Lake, for example, would destroy half the houses on Pender.

## Active Pass

The ferry backs out of Sturdies Bay and turns its bow into Active Pass. Doglegging between Galiano and Mayne, the 4.5-kilometre (2.8-mile) pass leads south into the wide sweep of Miners Bay, bends sharply to the right around Mary Anne Point and runs between the high bluffs to the north and forested Helen Point to the south, straight toward Mount Galiano. Widening glimpses of other islands appear as the ferry turns sharply south into more open water.

*Sturdy tugs haul log booms and scows through Gulf Islands waters.*

I always enjoy being on deck for the pass. Depending on the tide, the currents may be as fast as seven knots and sometimes present difficulties to the constant boat traffic. Other ferries, fish boats and personal craft all use the pass, but the busy waters are not the source of the name. After HMS *Plumper* navigated the pass in 1858, people informally called it Plumper Pass, a name still used in print as late as 1909. The captain of the *Plumper*, however, learned that officers of the US Navy vessel *Active*, a wooden paddle steamer, had already named it Active Pass after travelling through in 1855.

Passage was difficult in the age of sail, and HMS *Termagant* was nearly wrecked in 1860. In pioneer years the dangerous waters made Active Pass an uncertain highway between Galiano and Mayne, and several unwary rowers lost their lives in its swirling waters. As late as 1976, I saw the *Queen of Alberni* aground on Collinson Reef in Georgeson Bay. And when fishing was allowed off Helen Point, it was always exciting to see a mad scramble as people in a dozen or more small boats would fish until the last possible moment while the huge ferry bore down on them.

Glimpses of wildlife usually enliven a trip through the passage, making a pleasant surprise. In summer ferry captains sometimes announce a pod of orcas, and with a good pair of binoculars you can pick out Steller's sea lions hauled out on Collinson Reef or an eagle nest near the top of a Douglas fir. In fall you may see an irregular row of bald eagles resting in the trees along Helen Point or as many as 10,000 little Bonaparte's gulls fluttering over the water. In winter the pass may house as many as 4,000 Brandt's cormorants and plenty of Pacific loons. It's always worth being on deck.

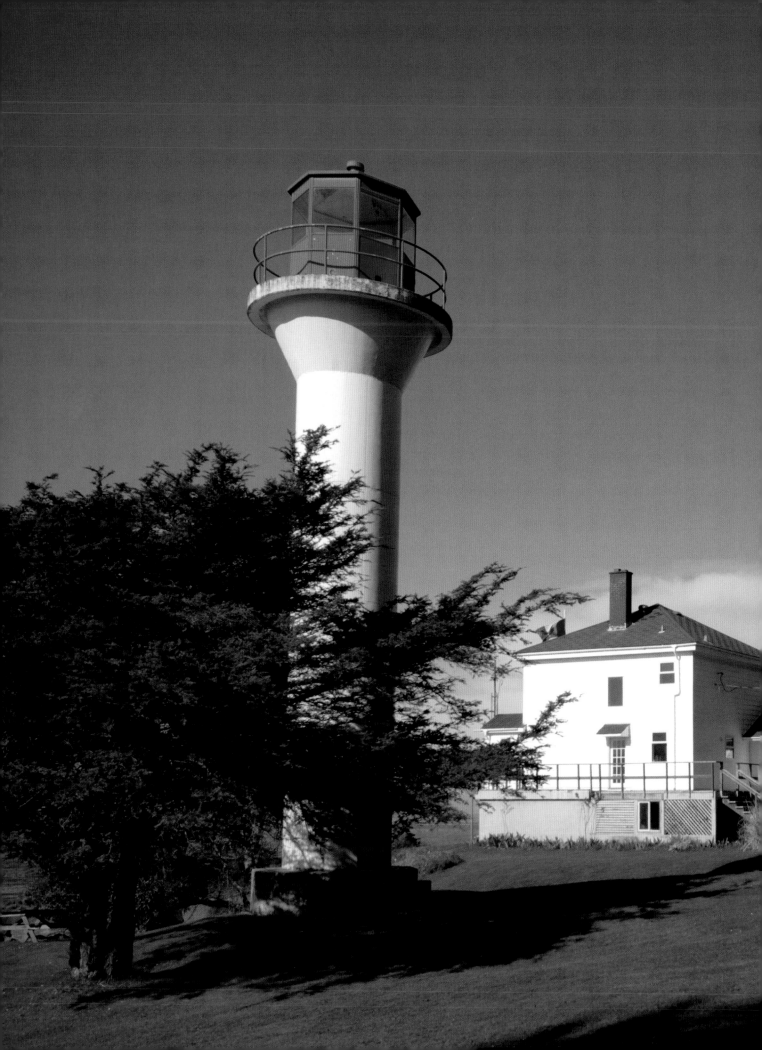

# 3 | Mayne Island: Tomatoes and a Lighthouse

# Enchanted Isles

In 1852 James Douglas, recently appointed governor of Vancouver Island, took a canoe trip from Victoria to Nanaimo to check out reports of coal deposits. Available maps of the area were inadequate, so he created his own map, which the Royal Geographic Society published in 1854.

Douglas could name only two islands in our region—Chuan, now known as Salt Spring, and Saturna—but did use Arro Archipelago (Haro Archipelago) for what we now know as the Southern Gulf Islands and the San Juan Islands. He called for a survey of the area as soon as possible.

Six years later, Captain George Henry Richards of HMS *Plumper* started to survey the islands. He named the large island north of Saturna after Richard Charles Mayne, his lieutenant. Mayne later wrote an entertaining book about his years on the coast, and in it he describes his 1858 survey work in the Haro Archipelago and particularly the San Juans. He refers later to "a pretty little group of islands" and the route through "Active Passage between Galiano and Mayne Islands."

Meanwhile Douglas's attention turned from coal mining to gold mining. Placer gold had been discovered on the Fraser River, and by 1858 British Columbia's first gold rush was under way. Many would-be miners found their way to Victoria by ship and made their unsteady way—in whatever vessel they could lay hands on—through the islands and across the Strait of Georgia to the mouth of the Fraser. Most took the direct route through Active Pass, where a convenient stopping place midway soon became known as Miners Bay. Successful or unsuccessful, some miners remembered the islands and returned.

The highest point on Mayne is Mount Parke at 261 metres (856 feet), which continues the same ridge as Mounts Sutil and Galiano on Galiano Island. From its summit beneath the navigation towers, the whole island's 23 square kilometres (about nine square miles)

*Mount Parke tops Mayne Island; Miners Bay is on the left. The radar installation helps monitor shipping.*

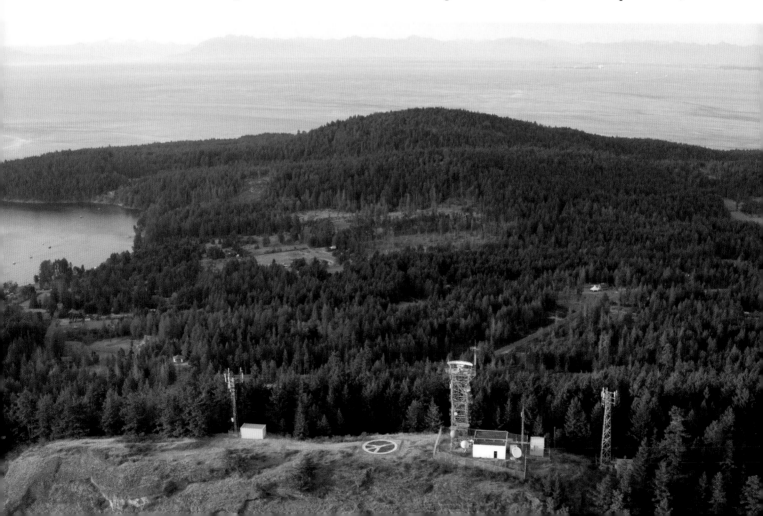

spread below, showing a typical structure for the Outer Islands. Stretching roughly northwest to southeast like Galiano, Mount Parke (partly protected in Mount Parke Regional Park) stands midway along the longest dimension, nine kilometres (about six miles) between Helen and St. John Points. Across its width of five kilometres (three miles) from Georgina and Edith Points to Dinner Point, low ridges of conglomerate and hard sandstone border Mayne; these end in points. The valleys between, formed by softer shales, end in bays.

Mayne has four park areas. The largest, Mount Parke Park, has enjoyable trails through the forested slopes of the island's most prominent mountain. The national park preserves Campbell Point and adjacent Georgeson Island as well as the Georgina Point light station. Dinner Bay Park includes an attractive Japanese Garden.

Mayne's historic Miners Bay houses numerous historic buildings and services. Other parts of the island provide a variety of accommodation, galleries and tourist services.

*Springwater Lodge, begun in 1890 and reputedly British Columbia's oldest continuously operated hotel, still welcomes arriving visitors at the head of Miners Bay wharf.*

*A young Mayne Islander tries his luck in Miners Bay as the sun sets behind Galiano.*

## Miners Bay: Little Hell to Heritage Village

One rainy June morning I stood on Miners Bay Dock. Before me lay Active Pass, which carried 19th-century miners from Victoria to a succession of gold rushes on the mainland. Later steamers travelled through.

Settlers landed here from 1861. American James Greavy came from Boston via New Brunswick, and Christian Mayers came from Wurttemburg. They settled in the broad valley behind today's village, felled and broke up the big trees by the laborious process of drilling holes and inserting hot coals, and split fence rails. Their sloop carried their farm produce to

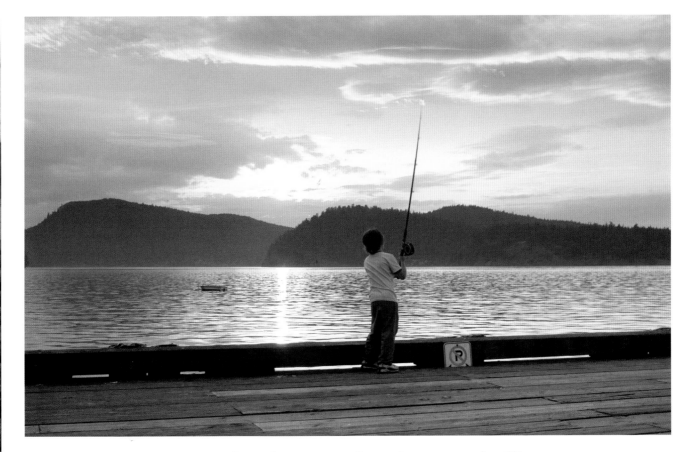

the accessible urban markets—Nanaimo, New Westminster and Victoria—each a day and a half's sailing time away.

Some later settlers had mined together in the Cariboo gold rush; others were Portuguese from the Azores Islands. John Silva, a Portuguese, came to Mayne in 1873 after jumping ship in Victoria and managing a grocery store there. He soon married Louisa, the 15-year-old daughter of a Cowichan chief, after giving his in-laws two horses and three sacks of potatoes. He brought his new wife to his dirt-floored log cabin on a 96-hectare (237-acre) pre-emption in Miners Bay and told her to bake bread. While he lit the fire his wife wept into the dough. Worse was to follow; two of their children drowned in the pass, and Haida raiders took their animals for food. Louisa made her husband take her to Gabriola Island around 1883.

Alice Bennett was unimpressed when she landed in 1879 at the new dock, the first in the Outer Islands. She called her new home "the arse end of the world." The long journey from Britain with her husband and five children may have coloured her first reaction, but she stayed to have three more children and bring a good many more into the world as midwife. Regular mail service began the next year, and the islanders needed a school in 1883.

Soon buildings clustered within reach of the dock; Miners Bay is the only remaining heritage village in the islands. Its historic buildings are older and more numerous than any other settlement's, and with little new development, the village preserves its original atmosphere.

Northward along the shore, Georgina Point Road is still a country lane that leads to the church and ultimately to the lighthouse. At the junction with Fernwood Road, at the head of the dock, arrivals from 1890 onward saw Tom Collinson's house. Its brick chimneys still

*Broad-leaved stonecrop brightens a rocky outcrop at Georgina Point.*

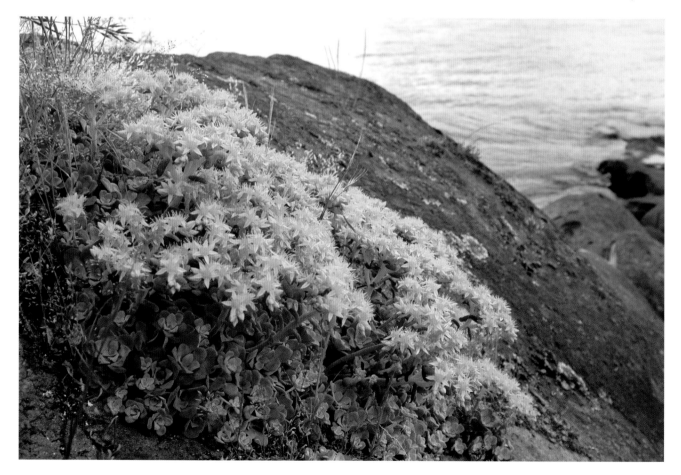

sprout from the core of Springwater Lodge, said to be the oldest continuously operated hostelry in British Columbia. It may have been one of the two establishments soon licensed to sell alcoholic beverages in the otherwise "dry" islands, leading to Mayne's reputation as Little Hell.

A solitary policeman patrolled this outpost of civilization in 1893. His responsibilities for "Plumper Pass and the Islands" stretched from the US border to the north end of Galiano Island and from the Strait of Georgia to Vancouver Island. In this extensive region—and on trips in search of criminals and lost property to New Westminster and even Seattle—the constable's usual means of transportation was a rowboat. In 1896 the government provided him with sleeping quarters and a jail, both in the same tiny build-ing. One of the few times anyone used the jail was in the 1930s, when the constable had to tie a handcuffed prisoner "under the influence" to the door while he found the key to his jail. Since British Columbia's 1971 centennial it has been Mayne's museum. A huge anchor and a block of sandstone from the 1872 wreck of the *Zephyr* stand outside. Across Fernwood Road, the Agricul-tural Hall (c. 1900), painted buff with green trim, still provides space for community events.

*A folk art carving lurks outside the Mayne museum.*

## Georgesons and Lighthouses

In February 1872, the barque *Zephyr* sailed south through the Strait of Georgia with a load of sandstone from Newcastle Island near Nanaimo bound for the San Francisco mint. During a heavy snowstorm the ship sank with the loss of two lives (the sandstone blocks were raised in 1987). Twelve years later the government responded to the wreck by constructing a lighthouse on Georgina Point, marking the east entrance to Active Pass. Charles Groth worked on its construction as a young German immigrant, and his father-in-law became the first lightkeeper.

Henry "Scotty" Georgeson was born in the Shetland Islands in 1835, ran away to sea at 14 and jumped ship in Victoria around 1856. He ran a "stopping place" on the way to the Barkerville gold rush with a Lillooet First Nation partner, Sophie, and by around 1863 they were on Galiano Island. Scotty fished, built boats and served on the Sand Heads light station before he moved to Georgina Point in June 1885. His government employer ordered him to marry Sophie before taking the job, which he held until he retired at the age of 86 in 1920, when his son George took over. After 1893 the lighthouse keeper sounded a new steam-powered foghorn when vessels gave warning of their approach. In 1918 the *Princess Adelaide*, approaching in thick fog, failed to give notice and went on the rocks near the lighthouse. Scotty's grandson remembered that the wreck looked "like a great big city."

The family lighthouse connection also involved Scotty's brother James, who in 1889 became keeper of the East Point light station on Saturna Island, built two years after another wreck drew the authorities' attention to the dangerous reefs. James's wife was the first white woman to live on Saturna, and their son Peter was the first white child born there. Since schooling on Saturna was inadequate, James maintained a cottage on Mayne where his older children could live while attending school and spent time farming there while his daughter looked after the light. After James's stroke in 1909, Peter took over and continued until 1939, when he moved to another lighthouse.

## St. Mary Magdalene Church

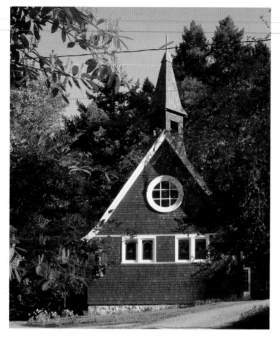

The first church on the Outer Gulf Islands was St. Mary Magdalene on Mayne. Its founders were widely travelled. Canon William Francis Locke Paddon trained in England, spent four years as a missionary in Palestine and married in Ireland. Bronchitis later led him to seek the "Garden of Eden" of Vancouver Island with his wife, nine children and a tutor. Paddon was a blood-and-thunder preacher who assisted the bishop in Victoria. Fortunately he was also tough and resilient; he was pulled unconscious from the Gorge Waterway after Victoria's famous 1896 Point Ellice Bridge streetcar disaster. In the same year he asked permission to begin missionary work to the Gulf Islands, without a stipend, in addition to his regular duties.

Previously, visiting clergymen had performed occasional weddings and baptisms in any available building. Now Warburton Pike of Saturna donated four acres (1.6 hectares) near Miners Bay for a church. Funds from England underwrote a steam launch for the minister and core funding for the church, consecrated in 1898. Until then services took place in a house on the property.

**Above:** *Consecrated in 1898, St. Mary Magdalene was the first church built on the outer islands.*

Representatives of six islands served on the church board. Two years later the building had a font, a natural rock basin weighing 181 kilograms (400 pounds), that Paddon rowed from Saturna's East Point with help from Pender and Samuel islanders in an 18-hour voyage—muscular Christianity indeed! Close links of this sort were typical of the Outer

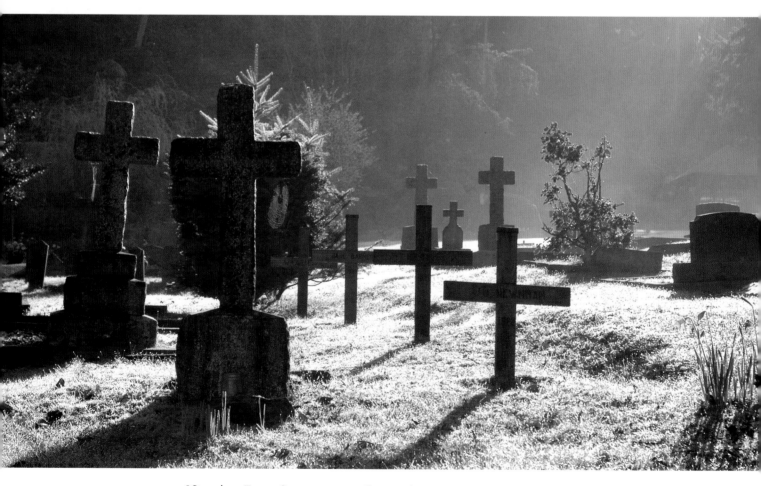

Islands in the early days. British ex-pats dominated the Anglican community, and no one considered it unusual to row to another island to attend church, get the mail or even go for afternoon tea and tennis.

The tree-shaded cemetery is now a little shrine to the early islanders. The Mayne Islanders are Bennetts, Georgesons, Paddons, Colonel and Lady Fawkes and Commander Maude. Arthur and Lilias Spalding of Pender Island lie here, as do some of the Galiano Bellhouses. The present ministers live on Pender, continuing this interisland relationship.

## *Tomatoes and Japanese*

Richard Hall, who came from a wealthy family in Cheshire, England, studied and practised agriculture in various places until he had a heart attack. He sold his James Island farm and moved into Mayne's Point Comfort Hotel for a rest. On his recovery he bought land around 1910 from the Maudes, who owned the hotel, and began hothouse farming. After returning from World War I, he built greenhouses big enough to allow horses to plow inside and hired Japanese workers.

*The Japanese contribution to Mayne's history is remembered in the Japanese garden at Dinner Bay.*

Japanese workers had visited the islands since the 1890s to cut cordwood for the canning industry. Some stayed to fish, found jobs with farmers and rented or bought their own land. When Hall lost money in the 1929 crash, a Japanese co-operative, the Active Pass Growers' Association, bought his farm. Soon they shipped five tons (about five tonnes) of tomatoes—worth $3,000 at the time—on the steamer twice a week. By 1938 a third of Mayne's population of 186 people was of Japanese origin and brought in an estimated half or more of Mayne's revenue. The Japanese played a strong part in the community, and their children went to the local school on equal terms.

When Japan attacked Pearl Harbor on December 7, 1941, Canadian authorities acted at once. Japanese had lived in Canada since the 1880s, many had been born there and some had fought for Canada in World War I. But racist attitudes were strong, especially in the cities. The government restricted their fishing and prohibited them from voting or entering certain professions. When war hysteria joined the combustible mix, the government arrested Japanese community leaders and forcibly relocated the entire population of Japanese origin far from the coast.

On Mayne, Zeiji Teramoto and three others were arrested the night of Pearl Harbor, and on April 21, 1942, other islanders saw off the remaining Japanese settlers at the dock, bound for inland destinations such as Southern Alberta or Salmon Arm in the BC Interior.

Kumazo Nagata asked friends to continue his business so that produce would go to market and his white employees would not lose their jobs. Other interned Japanese Canadians continued to give Christmas presents to their Mayne friends by writing to tell them where to dig up their concealed belongings. Non-Japanese Mayne Islanders tried to keep Japanese businesses going, hide valuables that could not be taken along—and until it became a criminal offence in 1944—bought land to keep for its former owners. Seventeen children were among those who left, so the Mayne school closed.

**Opposite bottom:** *Early islanders from Galiano, Mayne and Pender lie in the Mayne cemetery.*

Since the war a few Japanese families have returned, but their presence on the island has dwindled. Today's islanders have remembered the Japanese Canadian contribution to Mayne in the beautiful Japanese Garden at Dinner Bay Park, started in the late 1980s and extended and completed with much volunteer labour for a 2002 dedication. It features a pond, cherry trees and other plants—some contributed by original Japanese families—and traditional lanterns and fencing.

In 2007 Kadonaga Bay on Mayne was named in honour of the first Japanese settler.

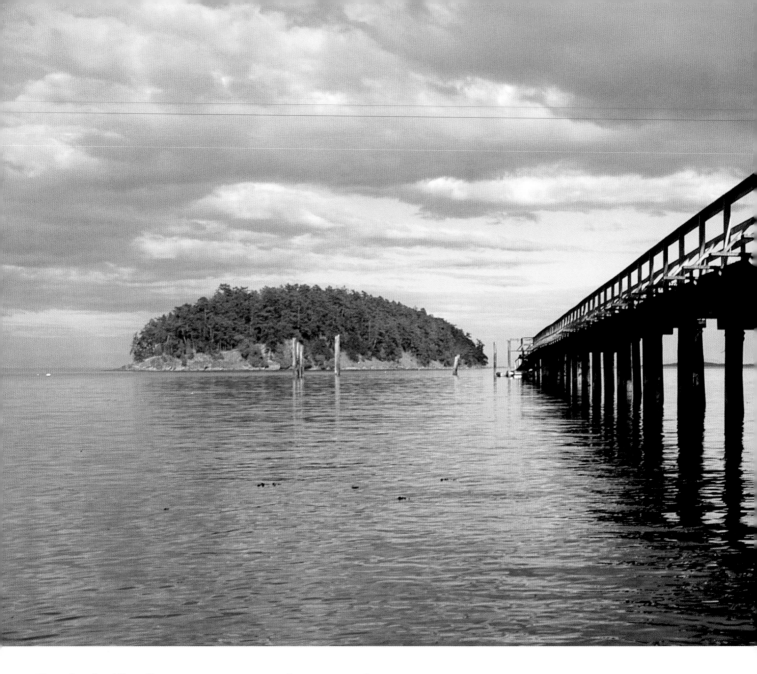

*Mayne Inn pier at Bennett Bay stretches toward Georgeson Island, part of the National Park Reserve.*

## A New Park on Parke?

A few years ago Mayne Islanders asked me to go over and help them identify some of the natural attractions of the Mount Parke area. We found many interesting geological features and plants, and the Friends of Mount Parke formed soon afterward in 2003. The existing Mount Parke Regional Park protects some of Mayne's loftiest slopes, but a large piece of the ridge remains in private hands. The Capital Regional District and the new organization tried to acquire additional land to protect the entire summit and ridge, but the owner wouldn't break up his 97-hectare (240-acre) parcel and sold the land to another private owner.

The organization transformed itself into the Mayne Island Conservancy Society. It now focusses on education and stewardship programs, publishing pamphlets to help landowners and tourists, and celebrating the greening of the earth with traditional May Day ceremonies.

"It's important," said founding president Helen O'Brian, "to tell people that you're only here for a moment."

The conservancy movement is widespread in the islands. Galiano's, formed first in 1989, has played a strong role in that island's controversies over forest land. It also runs education programs for island and urban children, is active in conservation mapping and ecological

restoration, and has developed a native plant nursery. Pender's conservancy movement followed in 1992, raising money to acquire Medicine Beach and Brooks Point, support coastal cleanup and operate an eagle watch. Since 1994 the Salt Spring conservancy movement has assisted in acquiring several properties. It runs an annual Eco-Home Tour and maintains a registry of big trees. The Gabriola Land and Trails Trust, started in 2004, is developing a guide to the island's trails.

The island conservancies hold regular meetings to discuss strategy. So far Salt Spring is the leader in radical consciousness and fund raising.

When clear-cutting threatened an endangered ecosystem on Salt Spring in 2001, naturalist Briony Penn emulated Lady Godiva by riding a horse through the streets of Vancouver, attired largely in a long blonde wig.

"We've tried everything to raise awareness about endangered ecosystems, but they won't listen to the scientists," explained Penn. "I've got a PhD, and no one listens. I take my clothes off, and here you all are."

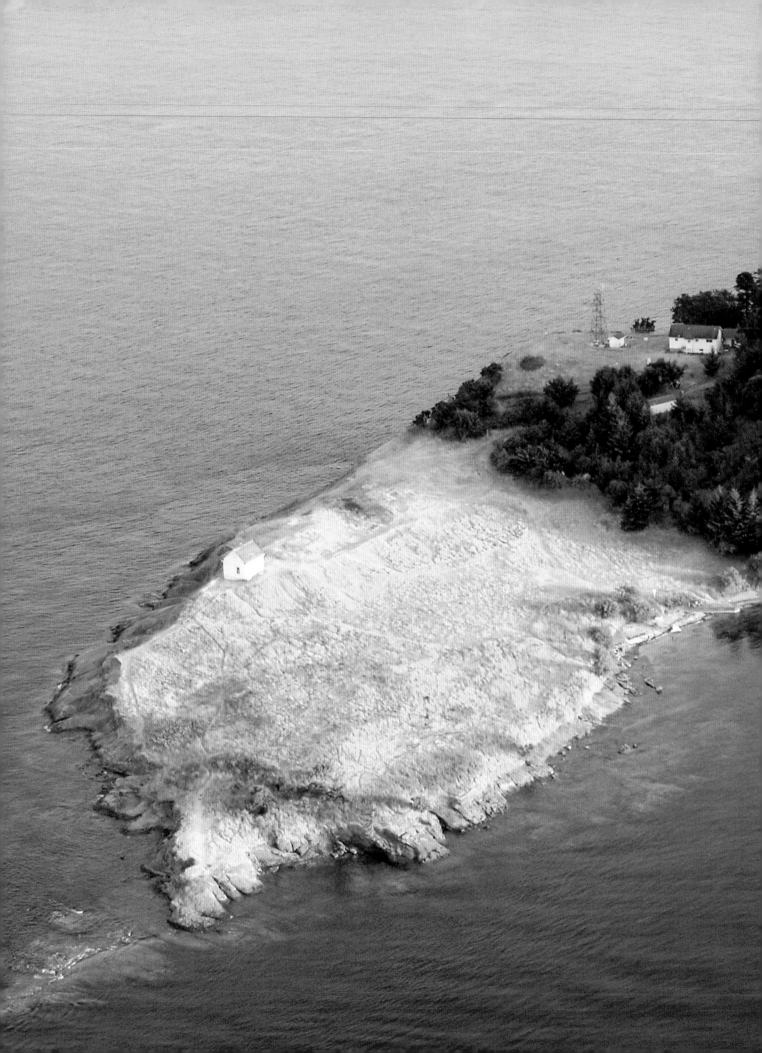

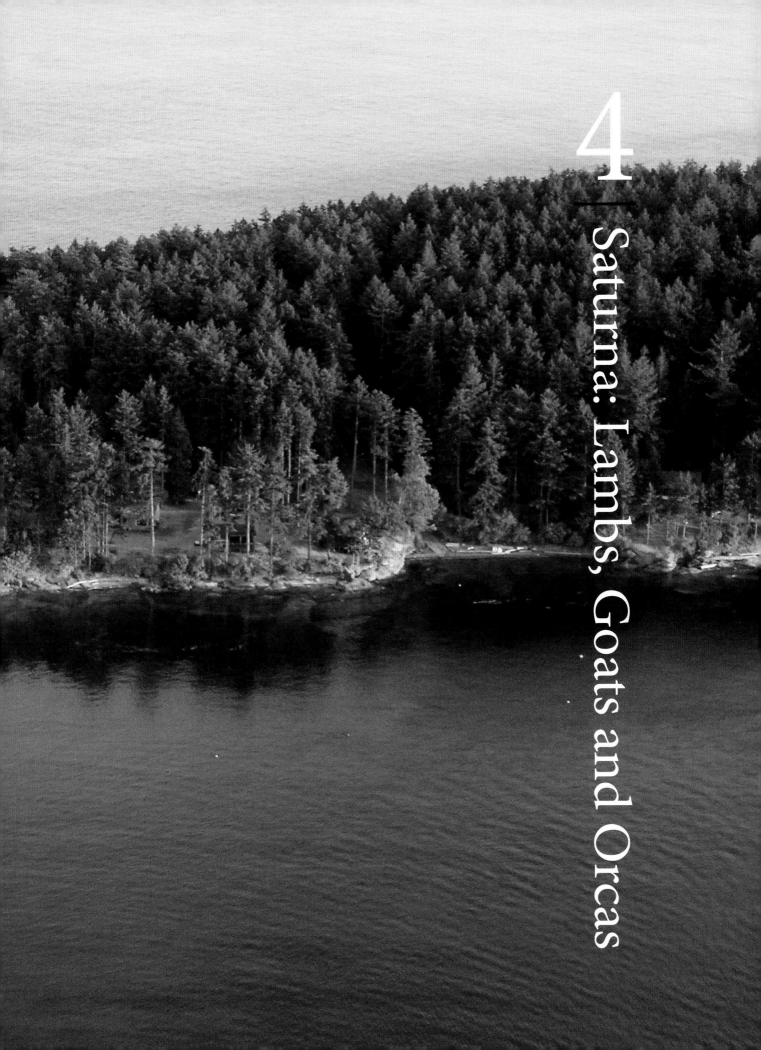

4 | Saturna: Lambs, Goats and Orcas

**Previous pages:** Tekteksen, or "Long Nose," is the Saanich First Nation name for East Point, the most easterly location in the Southern Gulf Islands.

In her autobiography *Trade Secrets*, Saturna resident Senator Pat Carney tells of a day when she answered the phone at a friend's B & B and took the caller's booking.

Later he said to the proprietor, "Your hired help sounds a lot like Pat Carney."

"Everyone says that," was her offhand reply.

There's a lot of Saturna in that protective answer. Saturna's population—359 residents make it the least populated of all the islands accessible by ferry—behaves a lot like a family, a big and sprawling one that does not always agree, that is usually friendly to outsiders but ready to unite in the face of an external threat.

From the ferry, as it approaches down Navy Channel from Mayne, the island appears as two humps separated by a valley. The humps are end-on views of ridges that continue the sandstone outcrops dominating the Outer Islands. On the left, a ridge from Mayne through Samuel Island rears on Saturna to Mount David and continues out to East Point, the easternmost reach of the Southern Gulf Islands. Tumbo and Cabbage Islands lie north of East Point. On the right, Mount Warburton Pike, at 497 metres (1,630 feet) the highest point on Saturna, continues in Brown Ridge to Monarch Head. In between, the deep cove of Lyall Harbour marks the western end of Saturna's central valley, and Narvaez Bay marks the eastern end. South of Brown Ridge, a broad shelf basking in summer sunshine has attracted farmers since early days and now supports Saturna's winery.

At 34 square kilometres (13 square miles), Saturna is almost as big as Pender. Residents cluster in the west end of the island around Lyall Harbour and Boot Cove, though houses are scattered along the other roads, especially East Point Road. Most facilities lie within a few kilometres of the ferry dock on the point south of Lyall Harbour.

The clannishness of the population is a result of Saturna's remoteness; it is normally necessary to change ferries to reach it from anywhere outside the islands. If this makes it hard for outsiders to get there, it is equally hard for Saturna residents to go anywhere else. But as

*Swallows and starlings nest in the old lighthouse buildings on East Point.*

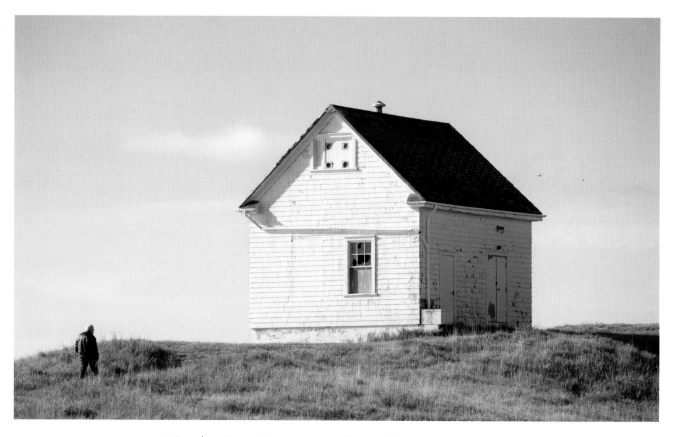

one resident said, "When you're on Saturna you don't want to go anywhere." Most people choose to live on Saturna only if they rarely want to go anywhere else or don't mind a long trip to get there. It is no wonder residents rely on their neighbours more than on off-island suppliers and services. Only people on nearby islands can easily get to Saturna; it is the Gulf Islanders' Gulf Island, a place to go when their own lives seem unbearably busy.

Saturna generally downplays tourism—the island does not have a single campsite— but it has one surprising public event, rather as if the neighbourhood recluse turns into a party animal once a year. For half a century the Canada Day Lamb Barbecue on July 1 has attracted increasing numbers of visitors and helps fund many island activities. Gentler public pressure has come from the development of the Gulf Islands National Park Reserve, which now occupies nearly half of the island and attracts tourists to its trails and beaches. The park includes most of the island's centre, the shore of Winter Cove and the south shores of Narvaez Bay and East Point. Outlying Tumbo and Cabbage Islands are also in the park.

## Five Paynes and a Pike

When Saturna needed a school, an ingenious method was used to select a site. Residents at each end of the island walked toward the centre and agreed to build the school where they met. This approach reflects the eccentrics of early days. The piratical Mr. Robertson tried to amuse children by taking them by the collar or belt and dipping them in the sea, without always bearing in mind their limited lung capacity. Walter Drummond, nicknamed Old Black, would wear his clothes until they nearly dropped off him, then seek out a friend with a bath and leave the friend to clean up the tattered remains and dirty bath while he took off in the best his host's wardrobe could offer. When one (former?) friend protested, Walter complained: "Your bally clothes didn't even fit me."

In this social environment, the eccentricities of colourful characters such as Warburton

*Sunrise from Cabbage Island silhouettes Tumbo, near Saturna.*

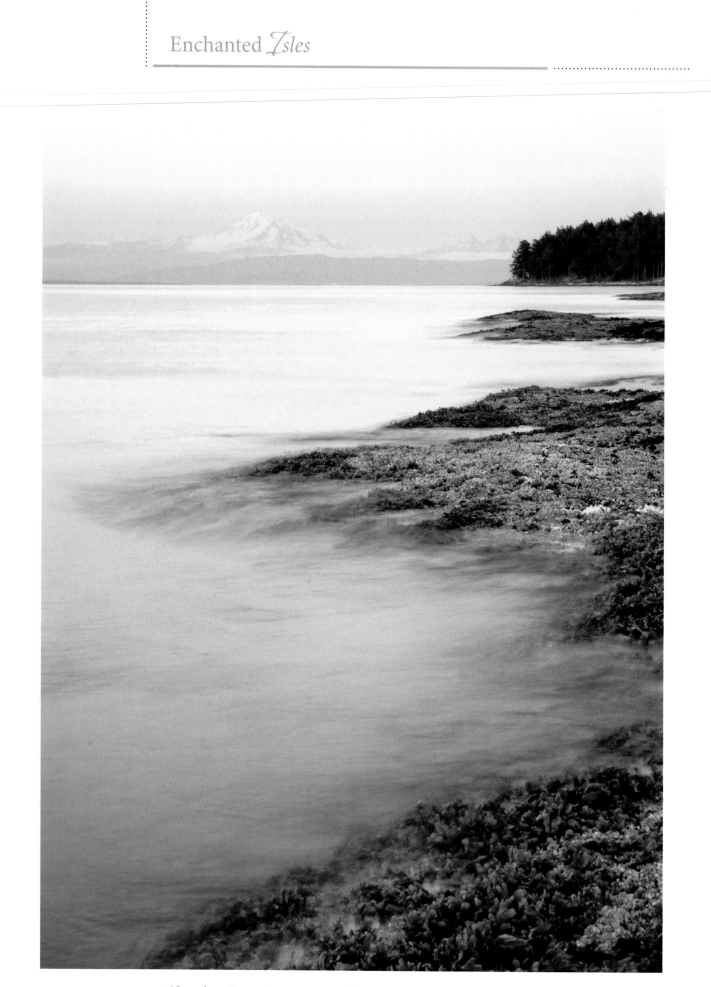

Pike and Charles Payne caused little remark. Pike and Payne, a pair of wealthy Englishmen, together bought 317 hectares (784 acres) on Saturna for $5,000 from one of the earliest settlers in 1884. Pike was born in Dorset in 1861, youngest son of a wealthy family, and he attended Rugby and Oxford. With this background he could have had a successful career in his own country, but when he received a substantial inheritance at 21, he dropped out of university, began travelling and contracted an "unfortunate" marriage.

By 1882 Pike was adventuring in America, looking for gold, cattle punching and hunting the prairies before ending up in Victoria. Here he met Payne, from a Manchester cotton-mill family, who was retired from the navy at 25. The two scouted the area for real estate, picking up land on Mayne and Vancouver Islands as well as Saturna. They lived for a while on the Saturna property, where they ran sheep, planted fruit trees, opened a quarry and commissioned a 14.6-metre (48-foot) steam yawl. Pike was an original; he travelled barefoot in rattlesnake country, preferred to sleep under a tree and washed his clothes by towing them behind his boat.

Pike soon went off canoeing in the Rockies, while Payne returned to England on business and brought back his brother Gerald in 1886. The young man spent his first night—and 16th birthday—sleeping in the fruit shed wrapped in a coat. Another brother, Harold, arrived on the island in 1891. He built a house near Winter Cove, opened a store and post office, farmed and fought in the Boer War before marrying Ruth, eldest daughter of the Mayne Maudes, who kept a large hotel. In 1893 the Paynes's father died; Charles as eldest became a baronet and returned to England.

Gerry Payne worked his brother's land for six years, then purchased 364 hectares (900 acres) of his own nearby. He built a house on what is now Payne Road, between Boot Cove and Breezy Bay, on land that "he cleared with the help of a huge ox called Bismarck

*Hubert "Parson" Payne made this chapel from a Japanese boathouse at Church Cove.*

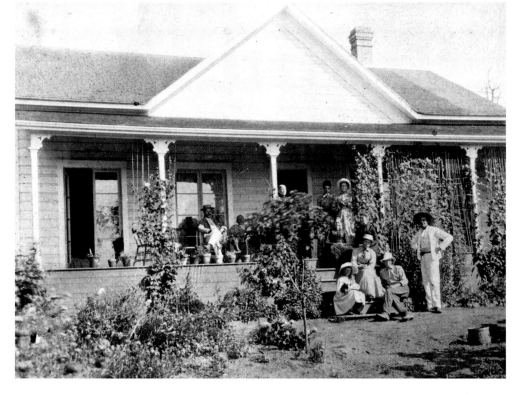

*Friends gather at Saturna home of eccentric adventurer Warburton Pike, 1888.* British Columbia Archives, B-07185

**Opposite:** *Mount Baker in the US Cascades dominates easterly views from the outer islands.*

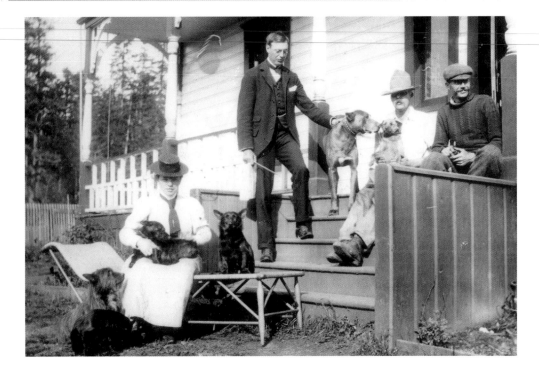

and . . . a Japanese named Sailor." In 1898 Gerry was one of a Saturna group that headed for the Klondike, running into Pike and Harold Payne who had started a trading post there. Gerry married Elizabeth Finnerty, a nurse from California, in 1899; they had a Chinese cook and added a nurse and governesses when their four children came along. Gerry farmed sheep with the help of Billie Trueworthy, a First Nations resident who became an expert shepherd, a friend to the island children and the island's bootlegger.

Harold's twin Hubert travelled to Saturna from Saanich on a stormy cruise that blew them to Thetis and Galiano and lasted a week. Nevertheless he settled on Saturna in 1902. Parson Payne—he had been ordained—converted a little Japanese boathouse into a small chapel that still stands on Church Cove and is visible from Winter Cove Road. His sister Isobel managed his house and once shot a cougar off her roof. She loved to wander away and paint, sometimes staying out so long that search parties were sent out to find her.

Pike was involved in island affairs, and his house was a gathering place for a group of English bachelors who also visited others on Mayne and Pender. They enjoyed cricket and cockfighting, still legal at that time even in England. Pike gave away some of his land on Mayne to provide sites for the church and the jail; he also financed and briefly was proprietor of the Point Comfort Hotel on Mayne. On Saturna he sold land on East Point to the government for a lighthouse. But Pike was also an explorer, remembered as "a mysterious and romantic character because he would simply disappear without a word and then appear back without a word." In 1889 he travelled north of the treeline in an expedition he described in his book *The Barren Ground of Northern Canada*. In 1892 he took another trip with Gerry Payne into northern British Columbia and the Yukon, described in *Through the Subarctic Forest*.

A bachelor despite an engagement and a few other romances, Pike (often with Gerry Payne) took less demanding hunting trips throughout British Columbia and Washington state during the next decade or so. But his talent for losing money was not totally neglected. He attempted to float a railway company in the Stikine Valley and prospected for gold in the area, then shifted his attention to steamer transport as the Klondike gold rush began to attract travellers farther north.

In his forties Pike continued his unprofitable commercial adventures and his expeditions, gradually shifting his attention from hunting to observation and photography. He sold his Saturna property in 1908 and acquired a house on Discovery Island close to Victoria. In his fifties Pike went to England when World War I began. In declining health and wealth, unable to find a way to help the war effort, he committed suicide in 1915.

## Mountains and Parks

Thanks to Gulf Islands historians who lobbied for the name, Warburton Pike is remembered in the mountain named after him, at the highest point of Brown Ridge. It is possible to drive along Staples Road to the top (thanks to the builders of the ugly TV towers on the summit), which offers spectacular views to west, south and east. On the south side, a steep broad grassy slope drops toward the sea, with occasional Douglas firs as sentinels. Here is a place to experience the special Gulf Islands pleasure of looking down on bald eagles and turkey vultures as they circle in the rising air currents along the slopes. The other Southern Gulf Islands and San Juan Islands are visible on a clear day, as are the Olympic and Cascade mountains beyond on the mainland.

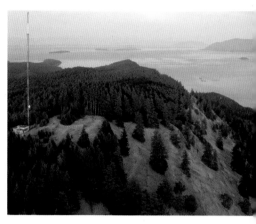

*Mount Warburton Pike and the Brown Ridge dominate Saturna's skyline.*

### Mountain Goats

Mount Warburton Pike is home to around 160 feral goats, usually travelling in three herds. Originally from flocks owned by Mrs. Gerry Payne and Mrs. G. Bradley-Dyne, they wandered loose during World War I, and goats from other domestic flocks joined them in the 1930s. The goats are mainly white but mixed with other colours. Though shepherds used to shoot the competing animals, and baby goats were occasionally adopted back into captivity, islanders have generally tolerated them on the mountain for many decades. They now present a management problem to Parks Canada.

The mountain marks the southwest corner of the biggest block of the southern Gulf Islands National Park Reserve, which occupies about half of the island. The centre block extends north to Mount David and Mount Elford on the northern ridge and runs east to Narvaez Bay. A big block of land on the south side of the bay almost borders it, and outlying pieces of parkland run along the south shore, on high ground west of Mount Warburton Pike and at Winter Cove in the northwest corner of the island. The trees are younger than the original old growth, but otherwise the extensive forests give an impression of the islands as they must have been before nonaboriginal settlement.

The park has a regional office near the community hall, which provides information about the limited trail system. In the central section a trail threads the upper waters of Lyall Creek, where islanders run a release program in an attempt to restore the original salmon. In an outlying block you can head down to the south shore of Narvaez Bay, where ducks and geese float on Little Bay and families of otters fish in Echo Bay. Another trail runs through the woods around Winter Cove to the shore, where you can see a spectacular current when the tide drops in the Strait of Georgia and water trapped between the islands races out through narrow Boat Pass.

## East Point and Moby Doll

In 1964 the Vancouver Aquarium commissioned a sculptor to make a life-sized model of a killer whale. The sculptor and an assistant set up a harpoon gun on Saturna Island's East Point. It was two months before they were able to shoot a young five-metre (16.4-foot)

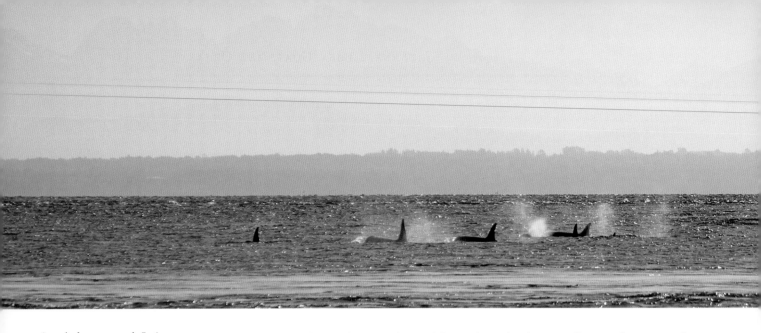

A pod of orcas rounds East Point where the first orca taken live was captured in 1964.

whale, one of a pod of 13. Other members of the pod tried to keep it afloat, and it survived even after it was shot at with a rifle. The aquarium director arrived by float plane, decided to try to save the whale and had it towed across to Vancouver, where it survived for nearly three months. A number of scientists examined it there, and thousands of visitors saw Moby Doll, which after its death turned out to be a male. This first orca in captivity provided an opportunity for important new research, led to the movement to capture and display orcas, and began a radical change in public awareness.

My first field trip for this book led me to East Point, where I was delighted to see my first orcas of the year in a big pod with at least five males and several females, surfacing in sequence so that the successive blows sounded like a passing steam locomotive. They swam from south to north outside Boiling Reef, where seals basked and gulls loafed, to avoid the strong current running in the opposite direction.

Even without orcas, East Point is a delightful spot. You can get there from the end of East Point Road on a narrow trail that detours around the modern lighthouse, which replaced the historic one built in 1887 and managed for many years by James Georgeson, brother of Henry at the Mayne light. The top of the point is a broad grassy plateau, broken up by windswept shrubs. You can enjoy broad views west along the north shore of Saturna and across to Tumbo Island, north to distant Howe Sound, and along the mainland shore around to the San Juan Islands and the distant Cascade Mountains in the south. Birds are abundant and interesting, and unlikely flowers survive the winds over the exposed point.

## Orcas

In the summer there's always a chance of seeing orcas. The southern residents live in the waters of Puget Sound and around the San Juan and Southern Gulf Islands. This group numbers around 80 whales in three pods known as J1, K1 and L1, which are so well known that scientists periodically publish a complete photographic catalogue. These whales are fish eaters, noisy and boisterous, which rarely move outside their familiar range in summer. One of their major routes, nicknamed the Orca Freeway, comes up the west side of San Juan Island and divides into two. One branch goes west around Mouat Point on North Pender and up to Active Pass. The other swings around Gowlland Point on South Pender and across to Saturna's East Point, allowing the whales access to the wide waters of the Strait of Georgia.

Less often, smaller groups of transient whales pass through the area. These are mammal killers,

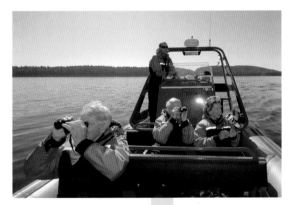

There she blows! Whale-watching boats follow orca pods through the Gulf Islands.

the ones that earned the name "killer whale" for the species. They are relatively silent, hoping to pass around a point or rock and surprise a seal or Dall's porpoise, which they may kill and eat.

In tourist season you can often spot a pod of whales from a distance by watching the behaviour of boats in the region. One or more whale-watching boats—often big Zodiacs with passengers decked out in brightly coloured exposure suits—may attract several small private vessels, moving slowly along in company with the whales or some distance behind them.

Thanks to the intense study, scientists have documented the fluctuating numbers of the southern residents. The first count yielded 67 whales in 1973, following a period during which an estimated 47 whales had been captured for aquaria. In 1999 scientists counted 83 whales, which declined to 79 in 2001. Although it rose to 89 by 2005, this population has been declared endangered in the United States and Canada, and is holding its own with 87 in 2007. Declining salmon, increasing pollution and pressure from whale watchers are among the factors that worry whale scientists.

## Treasure Islands

Few Canadians have visited Saturna, but many feel they know it. For many years the real island had a national literary presence through the newspaper columns of Jean Howarth. When she could, from the mid-1940s until her death in 2004, Jean lived on Cliffside Road out near East Point. But she had another life as assistant editor of the *Globe and Mail*, writing influential anonymous opinion columns. "Jean Howarth, more than any woman, stirred political thought in Canada," said her editor.

Yet for more than a decade, from about 1978, she took a break from stirring political thought by writing a twice-weekly column called "Treasure Island." Her Madronna Island is fictional but bears a strong resemblance to Saturna as it was when Jean first moved there. Only longtime Saturna Islanders can guess how much is "real" and how much is "fiction."

Madronna is populated by as bizarre a collection of eccentrics as you might find anywhere. It has an Indian reserve but only one Native family that came from somewhere else. It has Captain O'Grady, a bootlegger years after the repeal of Prohibition, but it also has a rock band and satellite signals. Its visitors include a professor of history, an entomologist and a bishop who requires forgiveness. Madronna residents support each other, share what they have and delight in banding together to defeat the inexplicable pressures of faraway government on this remote community. Two volumes of these Madronna tales were published in book form, as *Island Time* and *Secrets the Island Is Keeping*.

"Deep down," said a later editor, "we all wish we could live there."

In a way Howarth's Madronna stories present a little utopia, a mythical island where everything is different from the city and even tragic events are more bearable because the community is so supportive.

The islands have—directly or indirectly—spawned other mythological treatments. Saturna is also the setting for Eric Nicol's entertaining *When Nature Calls*, another little utopia even more full of threatening fauna and flora. Meanwhile Bill Deverell set some of his novels

*Early buildings, like this farmstead on Tumbo, were constructed of logs.*

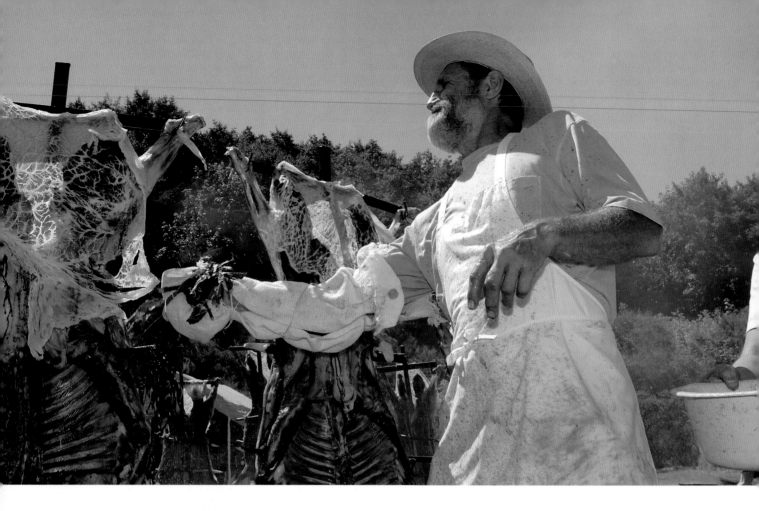

**Above:** *The lamb roast is the event of the year on Saturna.*

**Top:** *Chef John Guy bastes the lambs with a secret mixture at the Saturna Barbecue.*

on a rambunctious Garibaldi Island that bears more than a passing reference to his Pender residence. Bill Richardson's *Bachelor Brothers' Bed & Breakfast* (winner of the 1994 Stephen Leacock Medal for Humour) and its companion volumes are also set on a mythical Gulf Island, presenting a charming garden of eccentricity and whimsical challenge to all manner of conventions. Autobiography can also present a utopia, and the naive charm of Californian David Conover's 1967 *Once upon an Island*, an account of his Wallace Island paradise, must have set many on the island path.

Where there are utopias there will be dystopias, and a discernible vein of island humour says that everything is even worse than you think. Dystopias, which tend to imply they are nonfictional, perhaps start with Ed Gould's 1975 *Bridging the Gulf* ("a hilarious look at life in the Gulf Islands") and continue with Steven Grayson's 2004 *Rain and Suffering: The Real Gulf Islands Guide*. Jacqueline Watson's 1997 *Stuck on an Island*, shows a dark side of Salt Spring in an autobiographical counterpart to Conover's island dream. Fiction can be dystopian, too, and the horrifying "psycho-thrillers" by the pseudonymous Michael Slade include *Burnt Bones*, dedicated to "the Islomaniacs." Andrea and I were able to give some research help to author Jay Clarke, and the autograph in his book says, "Now you know how Dr. Victor Frankenstein felt." Indeed we do!

## Saturna Lamb

In 1950 Jim Campbell hosted a school picnic on Saturna Beach, a site on the family farm that is now a park. On our last visit in 2006, Jim was still carving barbecued lamb and heaping steaming meat on the plates of some of the 1,100 or so guests at the 57th annual Saturna Island Lamb Barbecue. The idea of barbecuing lamb came from Jim Cruikshank, a distant

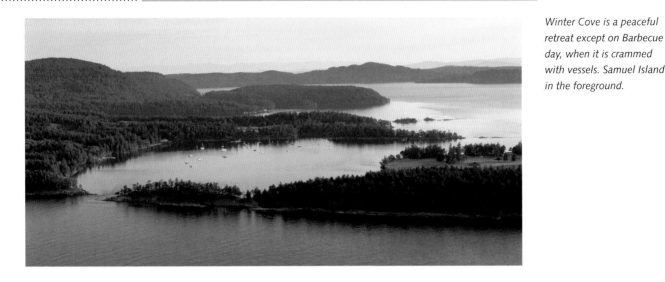

*Winter Cove is a peaceful retreat except on Barbecue day, when it is crammed with vessels. Samuel Island in the foreground.*

relative of Jim's family, after he came from Argentina to run a small flock of sheep on part of the Campbell spread. After a terrible winter he sold the flock but barbecued the last two in Argentinian style, spread on an iron frame in front of a wood fire, for the school picnic. His other innovation was to charge for admission and donate the money to the community hall. The islanders loved the idea, and a tradition was born.

The event is now the public face of a private island. It is highly organized and involves many islanders in a year-round cycle. Work crews cut wood, make coleslaw and undertake all the other tasks that are necessary to entertain over 1,000 guests for a one-day bash. Boaters come from great distances, and well over 100 craft fill up the harbour at Winter Cove, where Saturna has held its festivity since 1990. Other guests come by water taxi from adjacent islands and by ferry from Vancouver and more distant points.

A giant Canadian flag floats over the field, for this is Canada Day. Twenty-seven lamb carcasses stand spread-eagled in a circle around the fire, and the beer tent is ready to serve the suds. All morning guests drift in, listen to the live music, play games and talk to the National Parks crew and other public service workers who mount exhibits. People sing "O Canada," and 1,100 hungry guests line up to gather their lamb, eat, gossip, people-watch and doze in the sun.

*Saturna Island Winery pioneered viticulture on the islands.*

At the end of the day the guests head out, leaving the cleanup crew to restore the field and count the financial contribution to Saturna's public services and recreational programs for the next year.

### Falconridge, Falcons and Grapes

Saturna Vineyard, with 24.3 hectares (60 acres) of vines, is one of the largest operations of its kind in the province and now one of half a dozen in the Gulf Islands. Started in 1995, it harvested its first grapes in 1998. Its fourth vineyard, Falconridge, is named for the peregrine falcons that nest on the ridge above. The vineyard maintains a buffer zone and

operates without pesticides or herbicides to minimize disturbance to its vulnerable neighbours. Tours regularly visit the vineyard and taste the wines; in summer they can sample them with food in the vineyard's bistro.

Another vineyard, Morning Bay, operates on Pender; Garry Oaks and Salt Spring Vineyards are on the biggest Gulf Island.

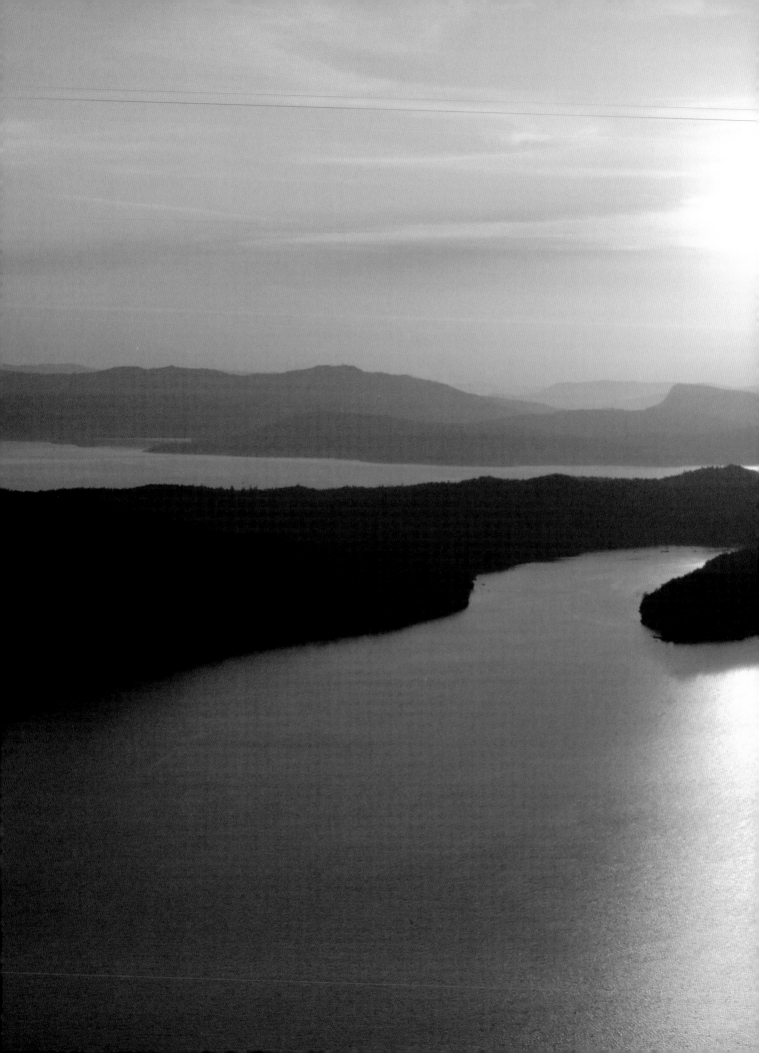

# 5 | Pender North and South: Good Land

*Previous pages: Pender Island in the setting sun. South Pender is to the left, Browning Harbour at centre and North Pender largely to the right. Beyond, Prevost, Salt Spring and Vancouver Island.*

An island, says the *Canadian Oxford Dictionary*, is a "piece of land surrounded by water." By that definition, for thousands of years Pender Island was a single island. Erosion gradually reduced the neck of land between Browning and Bedwell Harbours until there was only a narrow isthmus, across which it was possible to portage a canoe or rowboat. In 1903 a canal was cut through the isthmus to shorten a steamer route, and the two parts of the island became separated by a narrow strip of water. For the next half century the two parts of Pender Island developed some differences in culture that persist despite the building of a bridge in 1955, allowing overland traffic to resume. As a result North and South Pender Island, geographically two parts of a single island, have often been referred to as the Pender Islands.

A central spine runs through both parts of the island as a partial ridge from north of Shingle Bay on North Pender through Lively Peak to the canal, then rises to Mount Norman—the island's highest point at 271 metres (889 feet)—and on via Spalding Hill to Teece Point on South Pender. Four roughly parallel ridges run north of this spine on North Pender, and one runs south of it through Wallace Point and South Pender. In between are deep valleys, running into deep bays at Browning and Bedwell Harbours.

Pender supports a mixture of farmland and forest, with many trails and beach accesses. North Pender is larger and more varied at 27 square kilometres (10.4 square miles) than South Pender, and has the ferry connection at Otter Bay. In early years a number of industries operated here, but most traces of these have disappeared. Some 1,996 residents concentrate mainly in a few extensive residential developments, though most areas have a scattering of houses. South Pender is only nine square kilometres (3.5 square miles), and its population of only 236 lives on generally larger lots, mainly along the shorelines.

*Kayakers round the point of Roe Islet on their way to Otter Bay.*

The 2005 study shows 19 percent of North Pender and 28 percent of South Pender are protected. The Gulf Islands National Park Reserve includes substantial areas on North Pender around Roe Lake, the delightful point at Roesland and a patch of forest containing Prior Centennial Campground. The Loretta Wood area still has no trails. Other North Pender protected areas include George Hill, Medicine Beach and Oaks Bluff Park. South Pender has national park areas at Mount Norman and the adjacent former Beaumont Marine Park, and Green-burn Lake—perhaps the least disturbed lake in the islands—is worth the trek up a steepish trail. The unspoiled areas of shoreline at Mortimer Spit and Brooks and Gowlland Points are other favourite spots to visit, while Enchanted Forest Park represents inland forest.

### A Fossil Earthquake

The beach at the end of Bridges Road exposes one of the most interesting geological sites on the Gulf Islands.

Most of the Southern Gulf Islands are composed of rocks from the Upper Cretaceous, deposited around 85 to 65 million years ago. During this period many extraordinary dinosaurs rampaged around nearby Alberta, but the environment here was very different. The islands have produced very few fragmentary dinosaur fossils, unlike the Courtenay area, which has yielded numerous marine reptiles.

The rocks, collectively named the Nanaimo Group, would be about four kilometres (2.5 miles) thick if they were all laid out in sequence, but after deposition they were folded, faulted and tilted; in each island some repeat and others are missing. Thick sandstones and conglomerates form

**Above:** *The wood duck is a native species.*

**Below:** *Looking across Ella Bay at sunset.*

most of the outcrops, while softer siltstones and shales often lie under vegetation. The conglomerates—masses of rounded pebbles in a sandy matrix known traditionally as puddingstone—are most spectacular. Scientists have studied the pebbles from each layer and located sources for the different kinds of rock in nearby mountain ranges.

Gradually we've pieced together the story of a basin not too different from today's Strait of Georgia, filling at different times with sand and mud, where occasional floods brought down big pebbles. Most pebbles from the De Courcy Formation at Bridges Road Beach come from ancestral coast mountains.

The beach also shows the instability of the environment when these rocks were deposited; swirls of slumped mudstone include slabs of neatly bedded sandstone, whose elegant curves show that they were shaken from their sea floor bed before they had hardened into rock. Such an event could reflect seismic activity that occurred where an unstable slope built up during rapid deposition. I explain it to my grandchildren as a fossil earthquake.

## Xelisen: Canal Archeological Site

The Pender Canal was dug through the remains of one of the oldest villages in Western Canada. More careful excavations have produced abundant evidence of early inhabitants. Over the last 4,000 years, the isthmus supplied shelter and access to an abundance of seafood.

Clams were a favourite food, and, discarded close to home year after year, their shells built up a substantial pile of debris. Many shallow shores in the Gulf Islands are marked by middens, irregular heaps of debris largely composed of broken shells that gleam in the sunshine when the midden erodes. The canal midden contains more than the remains of clams. Near the north entrance, a green layer of sea urchin spines indicates another food supply. Residents also buried their dead, built new houses on top of old ones and lost or abandoned their tools, adding layer upon layer of information.

The first recorded Gulf Islands antiquarian was South Pender resident Herbert Spalding, son of pioneer Arthur Spalding, who gathered a collection of artifacts now in the Royal BC Museum. Professional investigation followed when the provincial museum's two small excavations in 1957 and 1958 dug through 2.4 metres (eight feet) of midden. An extensive excavation run in the 1980s by Roy Carlson of Simon Fraser University, carried out by students and islanders, explored the midden's remains on the North Pender side. A selection of the finds is on view in the Pender museum.

Excavation showed that the site flourished between 4,000 and 2,500 years ago, when evidence shows the development of a society with luxury goods and craft specialists. Varied adult burials suggest a social hierarchy. Some bodies lay on their side with no accompanying objects, while others sat in stone slab cists, some with an elaborately carved antler spoon at the mouth or a clam shell dish in the hand. The act of "feeding" the dead echoes the element of sharing food in the modern potlatch, suggesting that memorial ceremonies developed during this period. The spoon carvings, some alike enough to suggest the same artist created them, resemble later wood carving styles. One shows goat and eagle masks, suggesting development of the dances that are part of the modern potlatch.

Stone labrets (lip ornaments) and ear spools accompany some early skeletons of both sexes. It has been suggested that the male wearers may have been sea mammal hunters—an uncommon but prestigious activity—and the women wearers their wives. The islands may not always have been peaceful, as one skeleton showed damage to the forearm suggestive of hand-to-hand fighting. A possible house floor dates from the youngest period.

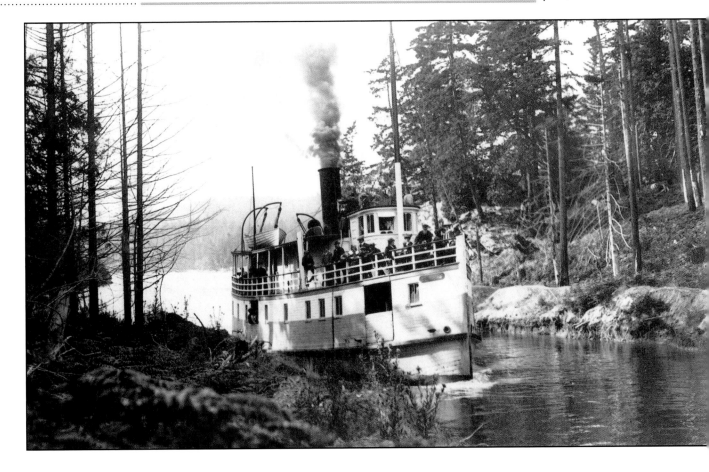

## SS *Iroquois*

Several historic photographs show SS *Iroquois* chugging through the Pender Canal. Built in 1900 and 25 metres (82 feet) long, one of many boats that served the islands in the days before BC Ferries, it had a stormier career than most. In 1902 it carried people from Vancouver's skid row to impersonate voters on the islands; they helped elect the *Iroquois* owner Thomas Paterson in a provincial by-election. Paterson promoted the Pender Canal to the federal government because the *Iroquois* was so unstable that he was reluctant to send it around Gowlland Point to Saturna in bad weather. She went aground in Nanaimo around 1905 but was refloated.

Sadly, her next adventure was less fortunate; she foundered off Sidney in a storm in April 1911. A good many Gulf Islanders were on board, and 25 people were lost. A monument in Pender cemetery records the death of Mrs. Hooson and her son Evan, but states baldly, "The child lies here," indicating that the body of his mother was never recovered.

*The Pender Canal was built for the* Iroquois, *seen here about 1906.* British Columbia Archives, F-00355

## *Arthur Spalding and Kloshe Illahee*

Arthur Spalding, who lived on the Saanich Peninsula for only a short time, "gained for himself a measure of notoriety by wearing red football shorts. Word soon spread that there was a strange young man going about the country in red underwear, accompanied by two large hounds," as his daughter Beatrice related in later years. His Airedales had travelled with him from Ore Place near Hastings in Sussex when he left home at 21 heading to California, then Oregon to learn sheep farming and Victoria to await passage home.

Back in Sussex he decided that he preferred the freedom (to wear football shorts?) he had enjoyed in the west. When he returned in 1886, Saanich friends brought him to South Pender, and at 23 he bought out an earlier sheep farmer. With his nephew Leonard Higgs, Arthur built a cabin, began to farm and formed the nucleus of a little colony that led to

*Douglas fir on Mount Norman.*

South Pender being called Little England. He joined other English expatriates such as Pike and the Paynes on Saturna in the pleasures of hunting and fishing, grass hockey, cricket, poker and Sunday morning cockfighting.

In 1889 Saturna's Warburton Pike was engaged to Agnes McKay, living in Victoria while her father Joseph McKay worked as a Hudson's Bay Company factor in Kamloops. With her mother and three sisters Agnes came to Saturna for a holiday. Pike did not get married, but Arthur and Agnes's sister Lilias became engaged and were married in November at Pike's house. Combining old and new worlds, Lilias wore a dress made in London for the occasion, but the newlyweds left for their honeymoon on South Pender in a "war canoe . . . paddled by two stalwart Indians." The Spaldings built up their farm; Arthur raised sheep and assembled a fine library, while most afternoons—between raising their four children—Lilias wove wool and developed natural dyes. Canon Hubert Payne, who visited to hold services in the Spalding house, in his eulogy remembered Arthur as "the best type . . . of English gentleman."

The Higgs family were also gentlefolk. Leonard Higgs had returned to England and married but came back to Saturna, then purchased land on South Pender in 1893. He named his house Kloshe Illahee—Chinook Jargon for "good land"—at the suggestion of a Pender First Nations resident and lived there with his wife Em. They were very isolated, and Em went to Mrs. Bennett, the midwife on Mayne, to have the first of her three children.

Leonard's sisters, Mabel and Winifred, came out to visit their brother in 1896, and the younger has left us a fascinating memoir of early life on the Gulf Islands. Travelling to Saturna by sternwheeler from New Westminster, Winifred and her sister were astonished to be put up for the night at short notice by Gerry Payne, and in the absence of a maid, were intrigued by the novel experience of washing up the dishes after breakfast. At Kloshe Illahee they found their brother's family living in a log cabin, and Winifred was puzzled to find that Em had a pantry full of preserves. ("It looked as if they must live on pickles.") "Forest fires raged unmolested," she notes, "filling the air with smoke for weeks, and blotting out all view of the mountains and islands," so that her first view of the snowy cone of Mount Baker was astonishing.

After a three-kilometre (two-mile) walk through the bush, Winifred was glad to see Arthur Spalding again and meet his young family. She was fascinated to see Arthur plowing with a yoke of oxen, and remarked that his wife Lilias was "a good shot" when she knocked off a deer that had been "devouring the crops." Arthur took two-day trips to Nanaimo to sell his sheep, and he and his wife also shared a position as South Pender's first postmaster.

The Spaldings' four children still have descendants on Pender. Winifred and her sister rose to the challenges of the islands, learned to row a boat, picnicked at the portage (site of the future canal), taught Leonard and Em's children, then bought land and built a house before returning to England. But the sisters returned the following year, and Winifred eventually married English bachelor Ralph Grey (a relative of a future Governor General of Canada) and moved to Samuel Island between Mayne and Saturna. Mabel lived with the

new couple until she married Martin Grainger, a novelist and British Columbia's second chief forester. Kloshe Road on South Pender reminds modern islanders of Kloshe Illahee.

## Sharp-tailed Snake

The Spaldings' third daughter, Beatrice, made an important contribution to the study of a rare BC snake. Dr. Lyall, surgeon of HMS *Plumper*, had discovered the snake somewhere on Vancouver Island in the mid-19th century, but it remained unconfirmed in British Columbia until one morning in 1944, when Mrs. McGusty (the former Beatrice Spalding) discovered a specimen in the middle of her garden path on North Pender Island. Mrs. Allan Brooks on South Pender found two more.

This intriguing little snake is rarely seen. Various shades of brown or grey, with a barred underside and a sharp tail, it can grow to 35 centimetres (about 14 inches). It seems to feed largely on slugs and seeks its prey at night under stones and logs. It has been variously said to thrust its sharp tail into the ground to help wrestle with its slimy prey, climb steep slopes or negotiate narrow burrows.

It has become known from a few locations in the San Juans and other sites in Washington state and on down into California. The few BC records mark the northern limit of the species, with an additional site near Chase in the Interior. David J. Spalding of Pender, Beatrice's nephew, found only a dozen BC records when he undertook a study of the snake in 1993, by which time Galiano and Salt Spring Islands had joined the list of localities, along with Nanaimo on Vancouver Island.

Study continues of this species, red-listed by the BC government as endangered or threatened, and now regarded as endangered in Canada. A covenant protects one habitat area on North Pender Island.

*The rare sharp-tailed snake hunts slugs underground.*
Photo Kriistina Ovaska

## Subdividing the Island

In 1963 Alberta residents found "full page ads in the Calgary and Edmonton papers, offering a chance to have a beautiful retirement home in the Gulf Islands," remembered Saturna Islander Jim Campbell. "Fly Air Canada to Vancouver. We'll take you over in a chartered plane to Pender Island to see these lots, and if you decide to buy one, we'll return your fare."

People could also buy lots at the Pacific National Exhibition in Vancouver for $50 down and get the rest financed at 8 or 9 percent interest. To city dwellers, the prospect was appealing.

Nearly 20 years after World War II, a whole generation was beginning to think of country cottages and perhaps of cashing in their high-priced city property before retirement. A market existed, and there was money to be made in development. It could even be seen as socially desirable; one realtor pointed out the advantage of building on the islands to save agricultural land in the Fraser Valley. Planning outside municipalities was unregulated, and the islands were unorganized territory, fair game for anyone with the dollars to buy land, draw up a plan and place an ad.

*Dead Cow Swamp was deepened and renamed Magic Lake by developers.*

Cy Porter, who had grown up on Mayne and now lived in Richmond, was one of the post-war developers. Working with a motel owner in Sidney he put down $5,000 on about 18 hectares (45 acres) in what is now the Trincomali neighbourhood on North Pender, and divided it into 66 lots. The partners added expertise as needed and soon had new partners, a real estate agent and the Vancouver surveying firm Matson Peck & Topliss, also involved in Magic Lake. There was no cash flow, and each partner took lots as their share of future profits. Cy negotiated an interim agreement with the first customer on the spot, and with a down payment of $400 the business was under way. Soon the company was selling lots on several islands and later added a franchise for prefabricated houses.

On quiet Pender, with a population of around 700, Porter then created Neptune Estates. Other developers soon followed with the development of British Columbia's largest subdivision, with over 1,000 lots.

Islander Noreen Hooper had come to Pender for her first teaching job over a quarter of a century earlier, when Lilias Spalding (then in her eighties) was still school trustee and provided board for the new teacher.

"Outside developers seemed overnight to have accomplished the creation of Magic Lake Estates on North Pender Island," she remembered. "A maze of roads was pushed through with such rollicking names as Schooner Way, Cutlass Court and Privateers Road." Even more startling to locals was the marketing of Dead Cow Swamp as Magic Lake.

Most lots comprised about 0.13 hectare (a third of an acre) of rocks, an area that was expected to provide room for both a well and a septic system. In 1965, when the government introduced regional districts, some Southern Gulf Islands found themselves in the Capital Regional District, which called for highways and health approvals. It was a painful experience adding water and sewer services in later years to much of Magic Lake Estates.

Despite older residents' alarm as the developers sold many of the lots, the impact was prolonged rather than sudden. Many new purchasers used their lots only for occasional weekends or let them lie fallow until they neared retirement. But Magic Lake had demonstrated the potential for rapid change and was to have major consequences for future development of the islands.

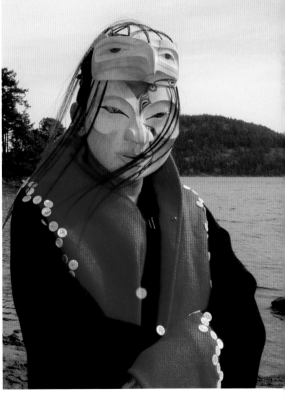

*Dancer wearing Raven Chief mask carved by island resident Victor Reece.*

## Bear Mother and Spirit Whales

Soon after First Nations artist Whè-la-ha (also known as Victor Reece) moved to Pender in 1996, he suggested carving a pole for Pender's new community centre. He envisaged it as a tribute to his mother and grandmother, so he felt that Pender women might want to help. Instead of the dozen women that Whè-la-ha anticipated might take an interest, more than 100 worked with him on three poles that were finally erected in April 2000.

Whè-la-ha came from isolated Hartley Bay near Prince Rupert, British Columbia, and studied his Tsimshian heritage at K'san, where he began carving and learned songs and stories. He then worked on a longhouse built for Canada's Museum of Civilization. For much of his time Whè-la-ha now works quietly in his Magic Lake workshop producing masks based on his heritage. In this role he is featured as a carver in Andrea Spalding's book for children, *Solomon's Tree*. He also spends time on the road, visiting schools and conferences around North America, talking of his mask making and storytelling with his drum or with

companies of dancers who wear his masks in performance. One of his masks has been given to the Dalai Lama.

Whè-la-ha's partner Wapase Panshi Equay (also known as Sharon Jinkerson-Brass) was raised in a mainstream Canadian family and rediscovered her Anishnabe roots as an adult. Her upbringing and her ancestry in Russia as well as Saskatchewan has given her a strong feeling for the cultural bonds between First Nations and the rest of society. "If we go back far enough, we all come from the same place," she pointed out.

After winning a scholarship to the Vancouver Film School, Wapase Panshi Equay formed the Big Sky Collective with Victor in 2001. With other artists she and her partner are mounting powerful multimedia performances with original music and video and masked dancers. The themes of Matriarchs of the Earth and Spirit Whales link First Nations traditions and social issues with the dilemmas of modern society. "Art," she said, "is medium and magic, and helps people to transform."

**Above:** *Melina Laboucan-Massimo performs in the mask dance, "Matriarchs of the Earth."*

**Opposite:** *Over a hundred volunteers helped Victor Reece carve these bear mother poles at Pender's community hall.*

# 6 | The Inner Islands: Prisons and Game Preserves

On September 17, 1924 a wooden boat was seen drifting in narrow Haro Strait between Moresby Island, one of the most southerly of the Gulf Islands, and the San Juan Islands in the United States. When the rum-runner *Beryl G* was taken in tow, she was found to be deserted—and heavily bloodstained. A tense search proved that hijackers from the United States had murdered her Canadian crew; they were eventually identified, caught and punished. This was one of many violent incidents in the history of the waters around the Inner Islands, now a peaceful paradise for boaters from both sides of the border.

Ironically enough, the sole casualty in the only "war" fought among the islands was a pig. The 1846 Oregon Treaty established the boundary between the American and British territories along the 49th parallel and through Juan de Fuca Strait. It left unclear the ownership of the islands in between, and both parties claimed them. In 1859 an American settler on San Juan shot a British pig at the Hudson's Bay Company farm on the island, precipitating what became known as the Pig War. A tense standoff between troops on both sides ended in peaceful joint occupation, until in 1872 the German Kaiser arbitrated a boundary through Haro Strait, confirming the Gulf Islands as British but leaving the San Juan Islands to the Americans. Some San Juan settlers of British affiliation moved to the Gulf Islands, and the scene was set for a smuggler's paradise.

*Princess Bay on Portland Island offers a sheltered anchorage.*

As American society and Canadian society evolved in different directions, it became profitable to smuggle goods and people across the boundary. The many little islands provided abundant hiding places for boats on illegal business and for caches of smuggled goods. Factories in British Columbia manufactured opium for the Chinese population, and it was profitable to smuggle it into the United States. It was also profitable to smuggle Chinese—people smuggling is not a new crime.

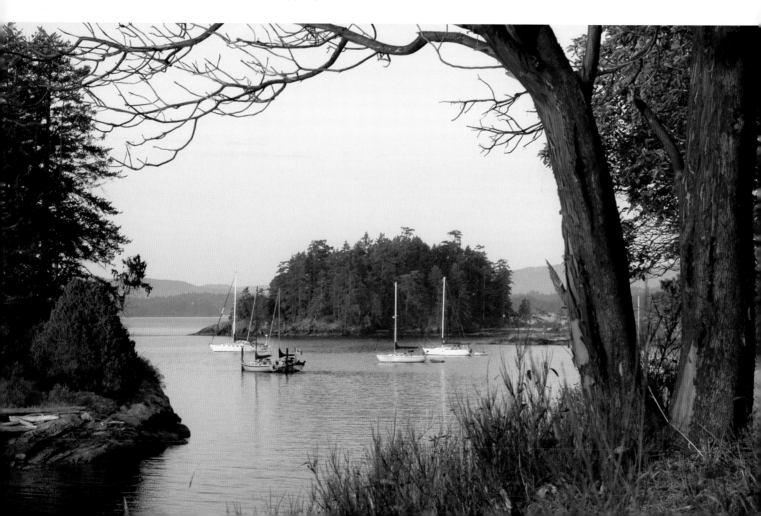

A well-known island character around 1896 was "a lovely old smuggler" known as Old Burke, who used to row across to Pender from San Juan Island "in his old, shallow skiff, stained grey-black to avoid detection." Alfred Burke offered chickens or tobacco in payment for what he wanted most—wool. "He could pay a good price for fleeces and make a profit on the other side, but it was a risky business for the old fellow." A steady trade built up, varied with rustling.

An even more spectacular opportunity occurred when both nations experimented—at different times—with prohibition of alcohol. British Columbia began in 1917, encouraging illegal transport north. When British Columbia gave up the experiment in 1921, America's Prohibition era had just begun, and until 1933 it was even more profitable to ship booze south to a huge and thirsty nation. Entrepreneurial Canadians like Johnny Schnarr, who built increasingly fast boats to evade capture, operated more or less openly. Experts used the complex channels to evade government men from both sides, for instance, slipping through Boat Passage between Saturna and Samuel just before the tide changed and made it impassable. Some rum-runners grew rich and were able to retire, while others were arrested, collided with floating logs at night, or got hijacked or murdered like the crew of the unfortunate *Beryl G*.

There are other dark aspects to the past of this region. Small islands have proven useful for prisons, of either people sick with feared infections or the socially embarrassing. Another island became an explosives factory. On the lighter side, some of the Inner Islands have supported farms or game sanctuaries or become gifts to visiting royalty.

Today they are within the Islands Trust region, and like all the smaller islands are managed under the mandate of the nearest large island, in most cases North Pender. Many of the smaller and wilder islands are now also part of the Gulf Islands National Park Reserve.

*A dead arbutus on Sidney Island provides a dramatic silhouette at sunrise. San Juan Island beyond.*

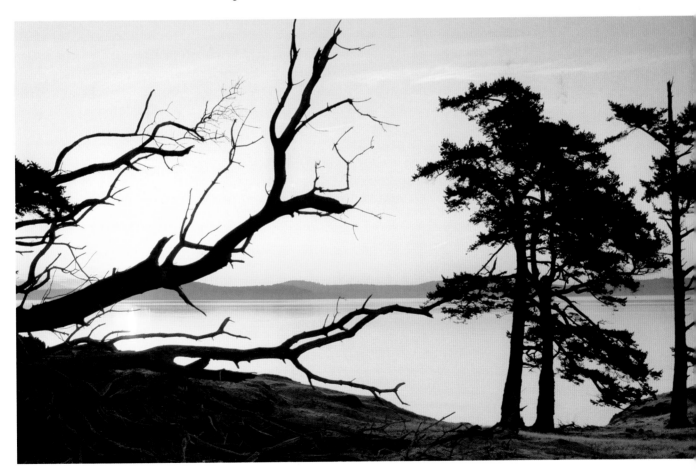

### Moresby: The Place to Leave Behind

The Saanich people called Moresby *Lo,le,cen* (the place to leave behind). More recent settlers knew it as Plum Island, after W.A. Hollins developed an orchard there after 1869. Captain Horatio Robertson, who left a career in China to import tea into Canada, acquired the island in 1888. He built an eccentric house for his wife, eight sons and three daughters, who were cared for by a Chinese couple. Robertson was soon at odds with his own family, First Nations in the area, his Chinese staff and the BC government, and launched lawsuits in every direction.

Things came to a head when his Chinese servants decided the island was a place they should leave behind. They escaped from the island on a raft, drifting for three days before being rescued. A Victoria paper published their story, and Robertson sued again. The judge agreed that the paper had committed libel—but that Robertson's reputation had not been injured!

## Sidney: Bricks, Herons and Spits

*Opposite: Scenic Sidney Spit at low tide, with Sidney village and San Juan Islands beyond.*

You can often see a group of masts across the water from the town of Sidney, as recreational boaters like to anchor in the shelter of the points on the north end of Sidney Island. The most prominent of these is Sidney Spit, extending the island to the north and known to Saanich First Nations as *Sktamen* (submerged by the waves). A water taxi from Sidney drops passengers at a wharf near Sidney Spit. Another curved spit, nicknamed The Claw, curves from a point farther south, protecting a lagoon that is a favourite swimming place for visitors and a fishing place for the many herons that visit the island. Within the lagoon is Eagle Island, one of several bald eagle nesting places in the area. Ducks, grebes, cormorants, auks and gulls are abundant year-round in the lagoon and other waters near the island. Just east of Sidney Island is Mandarte, where more than 1,000 double-crested cormorants nest.

The north end of the nine-kilometre-long (5.6-mile-long) Sidney Island is a former provincial park, now incorporated into the Gulf Islands National Park Reserve. First Nations came here for crabs, clams and fish, burned forest to encourage camas bulbs and left extensive middens. The Hudson's Bay Company tried to sell lots in 1860 but found no takers. Since then, Sidney Island has been stripped of most of its first-growth trees and used at various times as a brickyard, a hunting preserve and a sheep farm. The southern part now houses a residential development with its own airstrip and a sustainable forest.

### Great Blues in Decline?

The great blue heron is one of the most striking birds of the Gulf Islands. It catches the eye whether standing patiently in the shallows until a fish swims within reach, loafing on the mud flats between tides or flying with huge wings from island to island. When Robert Butler, an ornithologist

*A great blue heron nabs a minnow.*

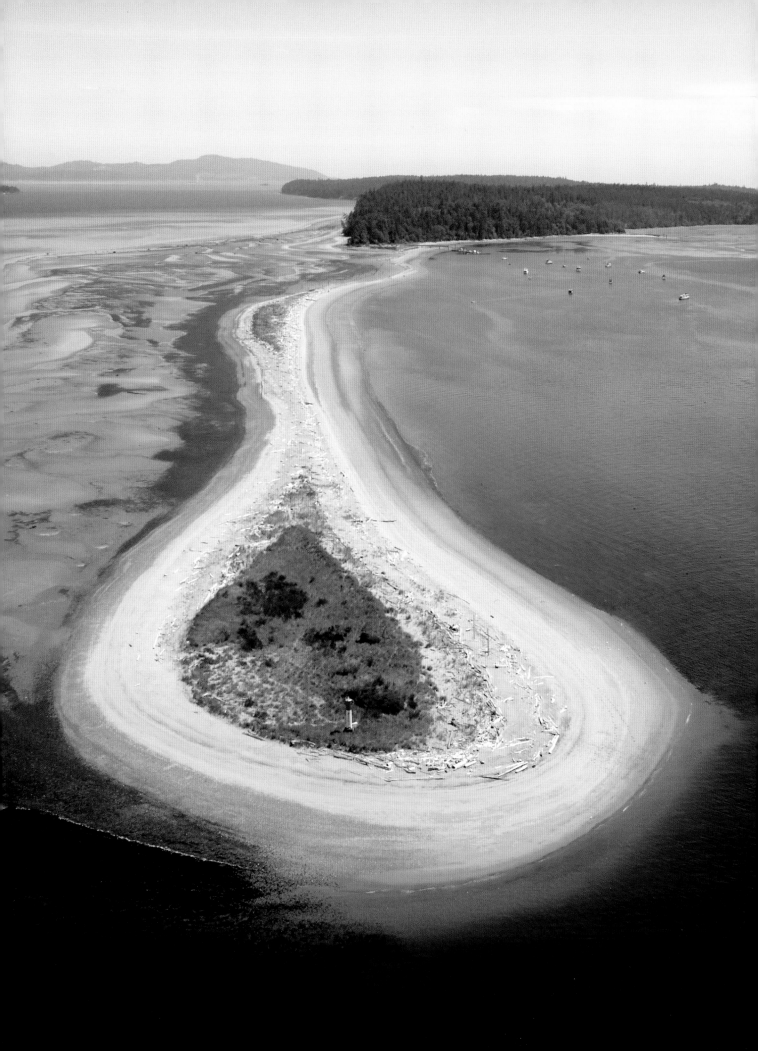

with the Canadian Wildlife Service and teacher at Simon Fraser University, began a study of great blue herons on the West Coast in 1986, he chose to study the bird's breeding behaviour on Sidney Island, where more than 100 pairs nested high in the alder forest. He found ways to count eggs without disturbing birds, watched heron fishing behaviour and seined the eel grass beds to count and measure the kinds of fish the herons were eating. The herons abandoned their habitat in the late 1990s after predation by bald eagles. Some birds may have moved to the McFadden Creek Colony on Salt Spring, which was established in 1990 and had 118 nests by 1996. Other birds now nest on Pender Island for the first time in years.

Recent research shows that, though still abundant, West Coast herons are declining at nearly 10 percent a year; scientists need more time to see if this is statistically significant. We know that herons are sensitive to poisonous chemicals in the environment, but Environment Canada observation reveals declining levels of monitored chemicals in herons.

## D'Arcy: *Lepers Marooned*

Leprosy, or Hansen's disease, is now known as a dreadful but treatable disease, often associated with the Third World. A traditional treatment with chaulmoogra oil proved effective in 1853, and researchers identified the bacillus responsible in 1874. But modern treatments were only developed in 1946 when a sulfa drug proved effective in curing the disease. Despite growing medical knowledge, people in the late-19th century often viewed leprosy with the same horror that medieval people reserved for the Black Death. Even medical authorities believed that they needed to isolate patients to protect society at large.

*Bull kelp floats in the morning mist off Sidney Island.*

During the building of the CPR, a steady of flow of Chinese immigrants arrived in Victoria, where a case of leprosy was identified in the early 1890s; later five victims were found

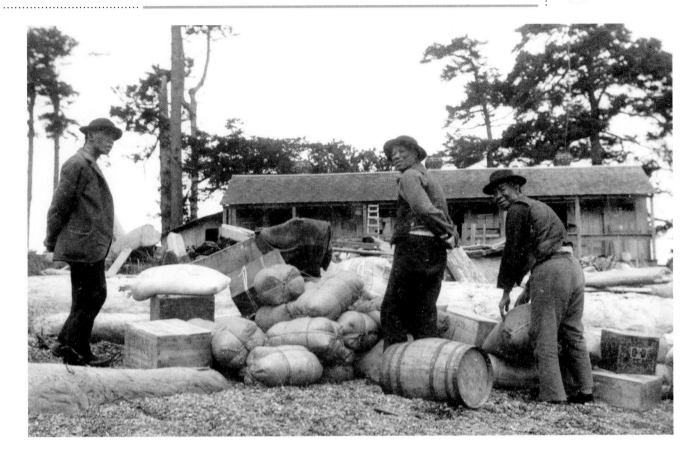

*Fresh supplies for D'Arcy Island's leper colony, c. 1897.* British Columbia Archives, C-03858

living in a shack in Victoria's Chinatown. The five were taken to D'Arcy Island, supplied with a building, food, fishing tackle and gardening implements, and left to themselves. They grew a garden, raised pigs and of necessity looked after their own needs. Every three months a boat brought supplies including food, clothing, opium and coffins—for the unfortunate victims were buried by the survivors. At first the city was responsible for the operation, but in 1906 it persuaded the federal government to take over. At that point the authorities erected new buildings on Little D'Arcy Island, east of D'Arcy, and provided a guardian and supplies that included the healing chaulmoogra oil.

Over the years nearly 50 sufferers lived on D'Arcy, as many as 20 at a time. But generally there was only a handful, including mainly Chinese men but also one European and one woman. Some residents were returned to China, but others remained until they died or were cured.

In 1924 the remaining five residents were moved to another isolation facility on Bentinck Island. D'Arcy became a marine park and is now part of the national park. Little D'Arcy is in private hands.

## *Broom and Bullfrogs: Invasive Species*

In the 1890s future premier Richard McBride and other prominent Victorians formed the James Island Club to provide an exclusive hunting preserve. They built a hunting lodge, introduced quail, grouse and pheasants, and finally added mountain sheep to the bizarre mix. A later owner brought fallow deer from the Duke of Devonshire's Chatsworth estate in England. (James Island later housed a World War I explosives plant). These introductions are merely the most prominent of a range of exotic species that have been introduced to the islands.

Curlew Island, off Mayne, still has peafowl and other exotics from earlier days; local people remember emus and llamas. Sidney Island had peacocks, wild turkeys and abundant fallow deer.

Intrusive plants are highly noticeable on all the islands; in early summer most turn golden with broom. On the Gulf Islands, this seems to have been largely the work of Canon Paddon, former pastor of Mayne. He loved the broom and carried its seeds in his pockets wherever he went, scattering a few in open spaces. He even used to enclose seeds in his letters, spreading the seed with the Word.

Originally imported to Sooke via Hawaii in the 1850s to provide cover for game birds, the glorious masses of yellow pea flowers on their dark green bushes reminded many homesick Britons of their homeland. Once liberated, the broom bushes did their bit for their own posterity, pushing their roots deep into the soil and scattering seeds from exploding pods in burned over forests and neglected farmland.

During the intervening century our perspective has gradually changed as we place a higher value on disappearing native flowers and regard the glorious broom as an invasive species to control wherever possible. Modern island residents gather for "broom bashes" to haul out the bushes like noxious weeds and burn them like witches. (One Penderian, Ursula Poepel, is so dedicated that she has been nicknamed Broomhilda.) Yet the broom still flourishes.

Even more noxious is gorse, a relative of broom armed with long vicious spines. South Pender residents wrestle with a whole gorse field, and it turns up on other islands from time to time. Invasive also but more attractive is the elegant pink campion that grows along many roadsides. Occasional holly bushes grow in the woods, self-set from fruit eaten by birds. The Himalayan blackberries that festoon roadsides attract pickers, while giant hogweed—whose

*Introduced by homesick pioneers, Scotch broom has a firm foothold in the islands.*

juice can cause blindness—has turned up in Drumbeg Park on Gabriola.

Game birds, deliberately introduced on several islands, include the pheasants formerly on Portland Island and California quail (introduced by Arthur Spalding and others) that people still occasionally see on North Pender. The commonest non-native mammals are the feral cats that seem to be an inescapable byproduct of pet ownership and support themselves on small birds and mammals. Abandoned dogs occasionally harass deer and sheep. Fallow deer escaped from a former deer farm on Mayne and are actively pursued. A single rat—such as the one I saw on my bird feeder recently—could wipe out an island colony of nesting seabirds.

Even species native to the country can have a devastating effect if introduced to an island where they do not occur naturally. Pender residents are recently complaining of introduced "cute" raccoons and loud-voiced bullfrogs.

A particular problem arises when an invasive species inhabits a national park area, as do the goats on Saturna. Should we see them as undesirable because they are non-native and have an impact on native species, or treat them as an interesting addition to the wildlife that contributes to park history? Park authorities are moving cautiously, studying the ecological impact of the goats before coming to any conclusions. They may help to control the broom, but they also encourage the spread of introduced coarse grasses. Saturna Islanders feel strongly about the issue. "If they're going to get rid of the goats because they aren't native, then they should get rid of the people too," said one.

## Piers: Doukhobor Prison

Minutes after leaving Swartz Bay most ferries pass Piers Island, a roughly circular dot on the map fringed with houses and docks. In 1932 this island became home to one of the strangest prisons ever constructed in Canada.

In 1899 Canada welcomed some 8,000 Russian Doukhobors (spirit wrestlers) as settlers for remote regions. Novelist Leo Tolstoy and the Society of Friends in Britain assisted

*Piers Island once housed a penitentiary for Doukhobor prisoners.* British Columbia Archives, G-000581

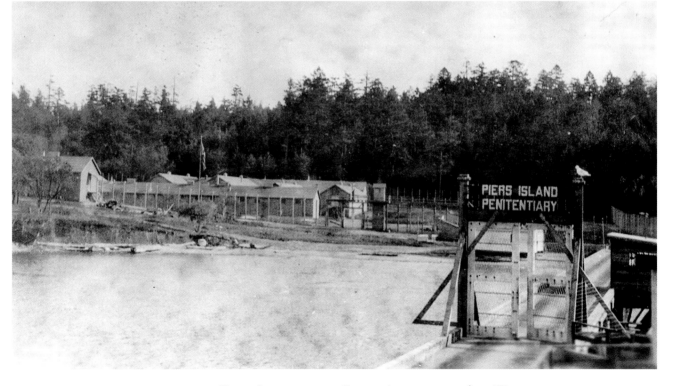

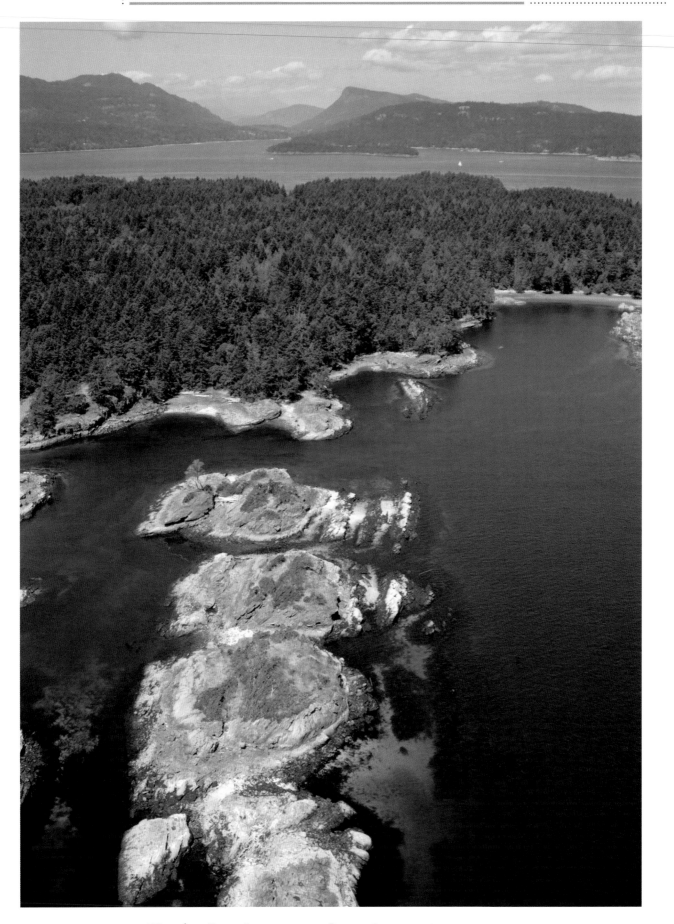

in their passage to escape persecution. Austere colonies of hardworking pacifists were not always well received by their new neighbours, however, particularly when they clung to their native language, resisted education and succeeded as farmers. Many found ways of living within their communities, but the extreme Sons of Freedom group hit the headlines in the 1930s when they burned down their schools and houses and protested in the nude. Threats of jail did not modify the behaviour of the sect, and after their series of bare-all events, the provincial government unexpectedly found itself the custodian of nearly 600 adults with mandatory three-year sentences for public indecency. The government also became unwilling foster parents of more than 300 children, whom they accommodated in orphanages.

For five years the government expropriated Piers Island, close to Victoria and with a single owner, and built separate but adjacent compounds for men and women prisoners. Then a quiet war between prisoners and guards ensued as both sides used passive resistance techniques. Inmates were expected to look after themselves; when they refused, guards left them cold and hungry until they chopped wood and began to cook. Nudity was not an effective protest in the absence of reporters and even less effective against wasps. The women, expected to make their own uniforms, insidiously decorated them with crochet and lace. No communication was allowed between the sexes, but loud hymns in Russian echoed cross the island and provided plenty of opportunity for inserting verses about Ivan's bad cold.

The stalemate wound down as the Depression deepened, and the government received letters of concern from Russia and English Quakers. It became expedient to release prisoners before their sentences were completed, some within a few months. They returned to their communities, but were not always welcomed. The government demolished their Piers Island prison in 1935 and no trace of it remains.

*A carapace of a red rock crab has washed up on the rocks.*

## The Princess and Portland

The BC government gave Portland Island, after a century of farming, to Princess Margaret during a royal visit in 1958. She was expected to return it at once, so that it could be turned into a park that could be named after her, but HRH had not read the fine print and failed to oblige. It took some years before the island (as writer Eileen Williston puts it) was "pried loose from the princess." The princess had offered to return it on permanent loan to the province by 1961, but the government was not able to commit to development until 1966. It became a marine park in 1967.

Senator Pat Carney of Saturna had a chance to clarify the matter when she hosted a dinner in the princess's honour at Expo 86. The princess mentioned Portland Island, and the senator asked why she had returned it. "The princess said candidly that it was too far away for her own use, and that her uncle [King Edward VIII who became the Duke of Windsor] had been criticized when he sold his Alberta ranch."

**Opposite:** *Pristine Portland Island is an important addition to the Gulf Islands National Park Reserve.*

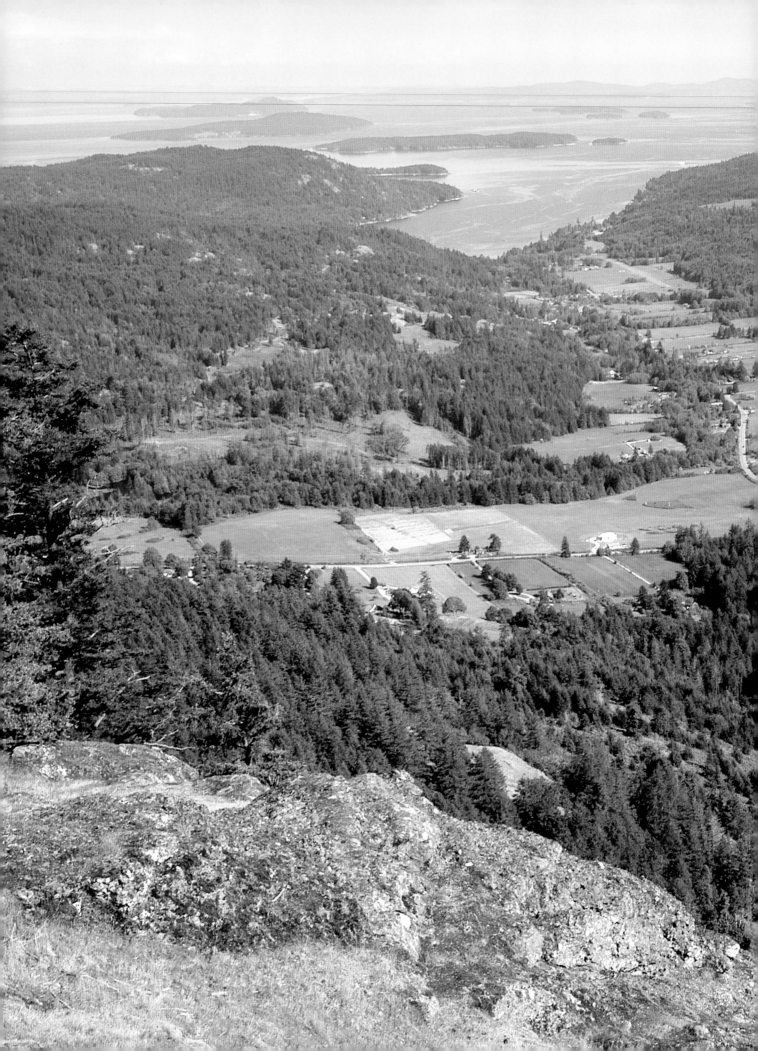

7

Salt Spring: Apples and Experiments

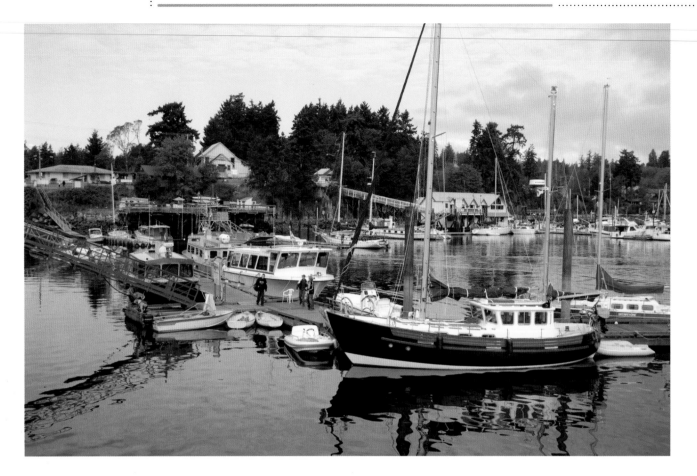

*The busiest harbour in the islands, Ganges serves school boats, float planes, and many water-borne visitors.*

Young Martha Akerman was gardening while her first baby Fanny slept peacefully in an apple box a few feet away. Turning around after a while, Martha saw a movement from the corner of her eye. A large cougar was sniffing the baby, but Martha did not hesitate for a moment. She screamed and ran toward the baby, waving her hoe. She was close enough to kick the big cat before it turned tail and loped off to the nearest cover. Her husband Joe returned later and shot the cougar before nightfall.

Although this tale is from around 1867, the time of early settlement, cougars have continued to visit Salt Spring. It is a short cougar swim across Sansum Narrows from Vancouver Island to Salt Spring. Cougars are attracted by livestock as well as babies, so conflict is inevitable.

It is a paradox that Salt Spring is the most urban Gulf Island and has the biggest population (9,780), yet such wild encounters are most likely to happen here. Salt Spring is also the largest island, at 27 kilometres (16.8 miles) long and over 14 kilometres (8.7 miles) wide, with an area of 187 square kilometres (72.2 square miles). It has the highest point, Hope Hill at 762 metres (2,500 feet), and the largest lake, St. Mary, over three kilometres (1.86 miles) long. It also still has much of the wildest landscape and lies closest to a source of large wild animals.

The island falls into three sections, each with high ridges divided by valleys ending in deep inlets. Long Harbour, where the ferry from Tsawwassen docks, deeply divides the northern section, with parallel ridges from Southey Point to the Athol Peninsula; this section ends where Booth Inlet comes close to Ganges Harbour. The central

*Mouat Bros. drygoods and hardware store is a Ganges landmark.*

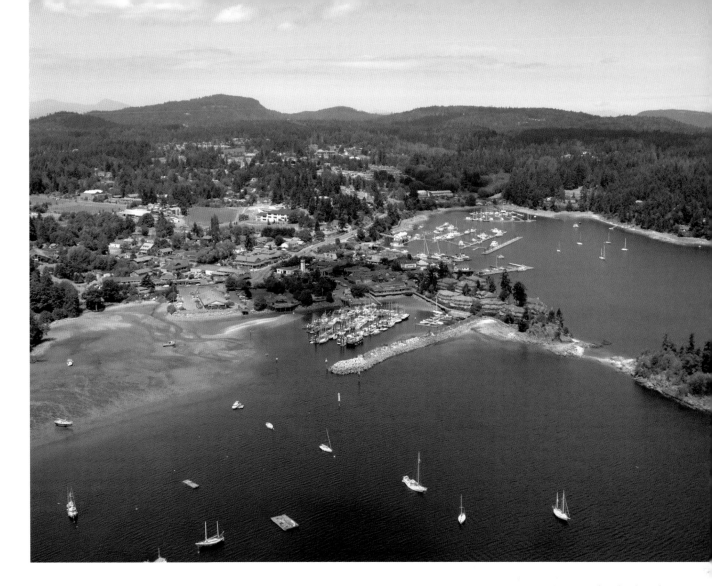

section runs in ridges and hills from Erskine Point eastward through Mount Erskine and Baynes Peak to Beaver Point. Between the central and southern sections, Burgoyne Bay and Fulford Harbour are linked by the Fulford Creek valley. A single massif in the southern section—rising to Bruce Peak, Hope Hill and Mount Tuam—stretches between Bold Bluff and Isabella points.

Geologically the northern section—composed of Cretaceous sandstones, conglomerates and shales—is very similar to the Outer Islands. The salty springs that give the island its present name are in this area. These rocks extend over the central section, but much older sediments and intrusive rocks lie below and emerge in the southern section, once the basin floor where the Cretaceous sediments were laid down.

The extensive lowlands were attractive to farmers, though they had to clear dense forests before they could work the land. Salt Spring soon took the lead in population growth, has the Gulf Islands' only real urban area—though Ganges is a triangular village only three streets deep—with the islands' only high school and hospital. More than most islands, Salt Spring has attracted painters, writers, musicians and other creative people, and these in turn have created a higher profile for the island and drawn the most visitors.

Salt Spring has two large provincial parks. You can enjoy the spectacular view from the top of 1,000-hectare (2,471-acre) Mount Maxwell Park, which also now stretches across behind Burgoyne Bay to the slopes of Mount Bruce. Ruckle Park, about half the size, occupies the southeast corner of the island and offers wonderful views of passing ferries from its shoreline trails. The parks will soon also include a new area on Mount Erskine.

*Ganges is the islands' only real urban area, complete with a high school and hospital.*

**Pages 81–82:** *Mount Maxwell offers a spectacular view of the Fulford Valley and harbour, Portland and Melville.*

## A Klootchman and a Clam Bed

"A log shanty, a pig, a potato patch, Klootchman and a clam bed," was the height of ambition of many settlers, according to explorer Robert Brown, who travelled among the Gulf Islands in March 1866. In Chinook Jargon, *klootchman* means a First Nations woman. From the earliest days of the fur trade, intermarriage with Natives was a recognized means of adapting to the new country, creating relationships with the residents and providing experienced assistance in the complex business of living off the land.

One Salt Spring resident who followed this approach was Michael Gyves, who arrived in 1863 from Ireland by way of the US Army, the Oregon Trail, San Juan Island during the Pig War and the Cariboo gold rush. He chose as his Native partner Tuwahwiye', a daughter of Cowichan chief Tusilum of the Clem-Clemelutz clan, and his wife Taltunaat. Born about 1845, Gyves's partner was later christened Mary Ann and became widely known as Granny Gyves in her old age. Her grandson Bob Akerman learned much from her about his Native ancestry and tells tales of all his Salt Spring ancestors in his family history, *Growing Up with Salt Spring Island*.

The First Nations of the Gulf Islands area spoke dialects of the Coast Salish language. Salmon, deer, ducks, clams and camas bulbs were among their sources of food; they made their houses and canoes of cedar. Natives from northern islands raided southern villages to take food and slaves, and counter-raids sometimes recaptured the lost people. The Cowichans travelled widely, using resources in different areas as they became available; for instance Tusilum paddled over to the Fraser River to fish. Southern Salt Spring was partitioned between the Cowichan of Burgoyne Bay and the Saanich of Fulford Harbour, but they

*Irishman Michael Gyves, right, settled on Salt Spring in 1863 with his native wife Tuwahwiye'. Salt Spring Archives*

shared each others' resources after asking permission; newcomers were less co-operative. Chief Tusilum retired to his Vancouver Island lands when settlers occupied Salt Spring, but he complained that he never received the compensation promised by Governor Douglas.

Bob Akerman was dandled on Granny's knee to traditional songs, part of the First Nations' rich cultural life of dance, song and story. He later heard of his grandmother's vision quest to the caves of Mount Maxwell, where she learned her personal wolf dance and song. Many years later Bob showed me around his museum, which continues to give pleasure to many Salt Spring visitors.

### Savage Animals Exterminated

When immigrant settlement began, there were a few bears on the island, which the Reverend Wilson recalled would "come around the ranchers' log huts and kill pigs at their very doors." But the "savage animals," he hastened to explain, had been "rigorously exterminated."

Bob Akerman's First Nations grandmother had many stories of wolf encounters, while his English grandmother Martha Akerman remembered being terrified by howling wolves on her first night on the island in 1863. Settlers killed the last wolves on Salt Spring by 1877. Wolves were still on Pender in the 1830s, according to First Nations stories told to Arthur Spalding, and on Gabriola till 1865. In 2000 a wolf that reportedly killed sheep on Saturna was eventually shot.

Cougars also lived on the islands before agricultural settlement. They are skilled hunters of deer, and since the larger wapiti (elk) were also present on Salt Spring, Galiano and Pender, the big cats did not want for food before domestic animals were introduced. The government offered a generous bounty, however, and there are many stories of cougar hunters on Salt Spring, including Joe Garner and Willis Stark. The next three generations of Akermans also continued to hunt cougars, and as recently as 1964 several Akerman boys and their friends killed three in one week. Other islands have cougar stories, too; Bill Lawson shot a cougar on Saturna in 1963.

## A Multicultural Society

In 1859 Governor Douglas allowed 29 immigrants to settle on unsurveyed land on Salt Spring without immediate payment toward the eventual price of five shillings (about $1.25) an acre. By the end of the year, 117 people had permission to settle on Salt Spring, although only about half followed through. But before very long, the lowlands of Salt Spring—around what became Ganges, Vesuvius and Fulford—supported a very diverse group of people. Blacks and Portuguese dominated the Vesuvius area; Scots and Blacks lived near Ganges; Irish, Norwegian, English and Hawaiian people settled in the Fulford Valley; Germans lived in the Beaver Point area. Some of the Britons had come via Australia.

Bob Akerman's other grandparents were English. Joe Akerman came from Wiltshire, England, in 1855 and married Martha Clay who came over on the "bride ship" to Victoria in 1862.

*The elegant white fawn lily appears in early spring.*

*Henry Ruckle arrived in 1872, and his farm is now the core of a popular provincial park.*

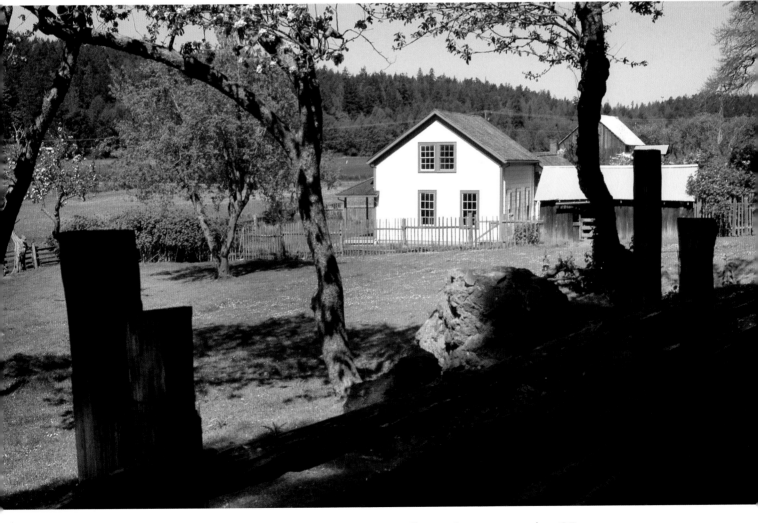

Life on the island was not easy. In addition to the settlers' usual struggles of trying to convert dense forest to productive farmland, a severe winter killed off many of the cattle and there was occasional violence. Smallpox raged among Native residents, who had no natural immunity. Early settlers witnessed dramatic battles between First Nations, like the one in Ganges Harbour in 1860, and a group of Haida robbed the island's first store in 1861. While settlers were forbidden to occupy aboriginal lands, this seems to have protected only the occupied villages. Many Natives must have been surprised to find trees felled and cattle or chickens living in their accustomed hunting or camas digging areas, and it is not surprising that some helped themselves to the new sources of food. There were protests, a few settlers were attacked and some died violent or mysterious deaths that others then blamed—rightly or wrongly—on local First Nations or passing raiders. It seems possible that some non-aboriginals may also have murdered aboriginal people.

In general, however, relations seem to have been good between all the communities. The 1881 census established that 45 percent of the marriages and 57 percent of the children were of mixed race. Mrs. Lineker, the first white woman on Salt Spring, is remembered as exceptional because she showed prejudice. As a "daughter of a Church of England Clergyman" she felt that she could not mix with Black people even in church. For a few decades it seems that most people accepted each other, approximating a successful multicultural society of a sort that is all too rare in the world today. It was only with the influx of more English people of higher pretensions that some elements of society began to look down on others.

## *The Stark Family*

A black man named Armstead Buckner was among the first group of Salt Spring settlers, and others soon followed, including the Stark family in 1860. Victoria at that time housed a number of black people, with the encouragement of Governor Douglas, who himself was of

*A face from the past, this petroglyph can now be seen in Drummond Park.*

*Born a slave in Missouri, Sylvia Stark lived 84 of her 105 years on Salt Spring.*
Salt Spring Archives

mixed blood. Some had come from the West Indies and others from California, where free blacks found their freedom impaired by laws that did not allow black people to give legal evidence against whites.

Louis Stark, the son of a white slave owner and his black slave, grew up in Kentucky. His wife, Sylvia Estes, had been born a slave in Missouri, but her family had bought her out of slavery. The couple married in California and came to Victoria with their first son, Willis. When the city proved uncongenial, the Starks re-established on Salt Spring and developed what may have been the island's first dairy herd. As they tried to establish themselves as farmers, two successive murders removed their hired helpers. Louis and Sylvia moved to a new site on Salt Spring, and in 1873 Louis moved to the Nanaimo area, where he died 23 years later, apparently also a murder victim.

Sylvia stayed on Salt Spring, where her son Willis still farmed. The 1900 log house they lived in is still standing. Many black settlers moved back to the United States after emancipation, but Sylvia stayed on to become an island matriarch, known as Aunt Silvey. When her son fell ill in his eighties, she is said to have complained, "I ain't never gonna raise that boy." And indeed she outlived him, dying at 105 in 1944.

### Maria of Russell Island

A cowry necklace on a grave beside the little Catholic Church of St. Paul at Fulford is the most striking evidence of another exotic group of settlers on Salt Spring and its neighbouring small islands. Hawaiians—then known as Kanakas from the Hawaiian word for person—gradually joined the labour force of western North America after Captain Cook made the first European visit to the islands in 1778. They became seamen and then worked on land for the Hudson's Bay

*Cowry necklaces on a tombstone at Fulford reflect Salt Spring's Hawaiian heritage.*

Company and other fur traders. Many married First Nations women, and some decided to settle down in British Columbia instead of returning home at the end of their contracts.

Thanks to Jean Barman's research, the best known Kanaka story is that of Maria Mahoi. Born around 1855 on Vancouver Island, Maria was the daughter of a Hawaiian father and an unknown First Nations woman. She married Abel Douglas, a Scots-American sea captain who was whaling in British Columbia; his parents had been in the California gold rush. Some time in the 1870s Maria and her family moved to the Beaver Point area on Salt Spring, where the 1885 baptism of her seventh child inaugurated the Catholic church. After Douglas left the family, Maria got together with George Fisher, son of an English remittance man and his Native wife. Together they had another six children. Sadly, George nearly drowned and was ill for some years.

In 1902 Maria acquired Russell Island, moved there with George and her younger children and in 1906 built a house that still stands. They grew fruit, fished and clammed, and sold produce through the local store. Maria died in 1936, and her island is now part of the Gulf Islands National Park Reserve.

## Comparative Ease and Comfort

In 1894 a visiting minister landed at Vesuvius and hiked across the island to Central, where he preached to a congregation of 22 in the recently built St. Mark's Anglican Church. Within a week he had returned to the island as the church's new minister. Reverend Edward Francis Wilson acquired the old Buckner farm for his wife Elizabeth Frances "Fanny" Spooner and their family of ten children and two First Nations girls, and shipped over a house addition and some fruit trees from his Victoria house.

Wilson, who had left England in 1868 as a missionary to Central Canada, wrote books about Canada's First Nations and advocated independent government. He and his family settled in the Salt Spring community, where his five daughters married farmers and sail-

*Russell Island, now part of the national park, was home to pioneer Maria Mahoi.*

ors, and one son started the golf club. Wilson farmed, led, exhorted, commented on and publicized his fellow islanders until his retirement in 1911. He left abundant writings in his personal journals, the parish newsletter and a pamphlet about Salt Spring that he wrote in 1895 for the provincial government to encourage immigration. Here he wrote persuasively of Salt Spring's potential for a farmer "to make a living and bring up a family in comparative ease and comfort."

## *As Regards Fruits*

"The island is particularly suited for the growth of apples, pears, plums and cherries," wrote Rev. Wilson in his pamphlet, topping his list of crops with fruit varieties. He was particularly interested in fruit and invented an "apple harvester" in 1904. He gives the melodious names of 14 fruit varieties grown at the time; his apples include Canada reinette, Blenheim orange, Duchess of Oldenburg and Gravenstein. Other farmers listed many other apple varieties including golden noble, Flemish beauty and brandy pippin, and jargonelle pears. An 1894 report enumerates over 17,000 fruit trees on Salt Spring.

*Some 350 varieties of apples grow on Salt Spring.*

Wilson names Messrs. Trage and Spikerman as the island's most successful fruit growers with an orchard of 1,600 trees. Orchardists claimed that trees grew much faster than in England, bearing after only four years, and they'd never known crops to fail. Apples sold for two cents a pound in Victoria.

In the days before canning and freezing, the aim was to have a variety of fruits that ripened at different times of the year, offered diverse flavours and could be dried or kept in cool places until needed. Grafting allowed several varieties to grow on the same tree. Rows of orchard trees are still visible on many Gulf Islands, the primary source of fruit for southwestern British Columbia's growing cities until the Okanagan began to flourish around 1900.

Gulf Islands orchards continue to serve local needs, and islanders have re-evaluated their resource in the last few decades. Commercial fruit growers increasingly concentrate on a few varieties that keep well in storage, but the wealth of heritage fruits in the Gulf Islands offers a range of flavours no longer available elsewhere.

Farmers rejuvenated old orchards, planted new ones and applied organic methods. Salt Spring, which now grows 350 varieties of apples alone, in 1998 established an annual apple festival. Every October several hundred fruit fans gather to visit orchards, see a couple of hundred kinds of apples, taste apple products, enjoy art and theatrical presentations, and take away a supply of delectable fruit for home consumption.

## *Rammed Earth and Blue Jeans*

When Paul and Becky Niedziela were insulating their house overlooking Stuart Channel, Paul drove down to Seattle and brought back a load of recycled blue jeans as insulation for the roof. Marcus Gasper and Eva Kuhn are powering their rammed earth house with a wind vane sprouting from the young arbutus trees that forest their hilltop above Captain Passage.

Salt Spring has so many experimental houses that every year the Salt Spring Island Conservancy runs an Eco-Home Tour of around 10 houses and schedules a sustainable building forum. Recently we were among the more than 400 people who bought tickets for the

*In 1895 Henry Ruckle had
600 trees in his orchard;
some of them still bear well.*

tour, which sells out every year. The island is one of the pilot projects of British Columbia's Sustainable Building Centre, a service agency for the provincial Save Energy Now program. The innovations stretch the boundaries of conventional building; when I talked to Paul, the government had not yet decided on a standard for blue jean insulation, so he had had to find an engineer willing to certify that it met the code and was equivalent to R32 insulation.

People are experimenting with building materials and adapting ancient traditions to modern needs. Rammed earth has been used in China for thousands of years but is new to Canada. The art lies in mixing the particle sizes of silt and sand so that it packs rigidly, providing high insulation value and the strength needed in an earthquake zone. Cob, a technique adapted from European folk tradition, uses clay, sand and straw and is suitable for cold-climate construction. Adina Hildebrandt and Andrew Haigh were living temporarily in a yurt—a Mongolian mobile dwelling—while building a house of hemp straw bales, which will be solar-powered with an electrical generator for backup.

Other builders are designing innovative water systems. One uses a metal roof, water tanks under the house and a grey-water system for irrigation; another minimizes electromagnetic radiation from electrical systems to reduce potential threats to health, and others depend on active and passive solar heating.

Paul and Becky Niedziela's house is insulated with recycled blue jeans.

## *Artsprings Eternal?*

In January 2007 Dawson Creek's singing son, dramatic tenor Ben Heppner, touched down on Salt Spring for a concert before heading out for the Metropolitan Opera in New York, then Paris and Vienna. Salt Spring has a theatre, nestled in a corner of Ganges, in which Heppner could feel at home. With 256 seats, it's a little smaller than the Met, but it's the biggest and most active theatre in the Gulf Islands.

Salt Spring islanders raised much of the funds to build Artspring, which was opened in 1999 by artist Robert Bateman. The Artspring building also contains a 483-square-metre (5,200-square-foot) visual arts gallery and multi-purpose area. "We put on our own events," explained Director George Sipos, "and provide facilities for other organizations." There is an ambitious music program. Each winter there are eight classical events, four jazz events, and another three or four special events that recently included not only Heppner but the Baltimore Consort, a group from Zimbabwe and comedian Lorne Elliott. A summer festival features jazz, roots and world music.

Heppner is not the only star at Artspring. Grace Fong, winner of the Leeds Piano Competition, launched the Salt Spring Piano Festival in June 2007. "It was a natural," Sipos explained, "because we have a good Steinway. We're being a little like Banff, bringing a talented performer and some students together to learn and give concerts." There are also plans for dance and theatre seasons.

Funded by ticket sales and assisted by regional, provincial and federal grants, the centre depends on some 3,000 volunteer hours a year.

## *Make It, Bake It or Grow It*

Salt Spring's Saturday market is a destination all on its own. Between April and October, all morning to early afternoon, more than a hundred artisans strut their stuff in downtown Ganges. Their wares—all homemade, home-baked or homegrown—occupy several rows

of colourful booths that stretch along the edge of the park. Street performers mingle with the sauntering crowds; the air smells of coffee, soap and spices, fresh breads and sizzling pot stickers; guitar pluckers and Chakra chimes provide a resonant background to the buzz of conversation. Come for five minutes and you might stay all day.

Stalls mingle in endless variety. Among the apples and veggies, you'll see flower displays so extravagant that the proprietor is lost in his own jungle. Andrea was taken with Sacred Mountain Lavender's display and bought their Cracked Lavender Pepper and other culinary delights.

Stalls offer a variety of wearables, from felt hats to batik fabrics, which you can accessorize on the spot with bags and bangles. Crafts include pottery, woodwork, twig baskets, folk sculptures and colourful candles.

There are more exotic offerings too. You can soon find yourself discussing a book with a self-published author, booking a kayak trip, lining up a course in photography or even dreaming of an art holiday in Asia.

The number of people watching—and chatting—is terrific; I connected with an unrelated sharer of my rare surname and talked to Joan Phipps, a former leading female jockey of such repute that she'll soon be the subject of a film.

When you're tired and need a quick snack, try Ometepe fair trade coffee with chocolate chip cookies or organic bread, or nibble on local cheese. And if all else fails, you can always take a muscle-soothing break at the Massage Oasis.

*A giant pumpkin attracts an admirer at Salt Spring's fall fair.*

*Great garlic at the Saturday market.*

*Above: Hand-blown glass is only one of the crafts on sale every Saturday.*

*Below: Buy your produce with Salt Spring dollars, or take them away for souvenirs.*

### Salt Spring Dollars

Don't be surprised if your change at the market—or anywhere on Salt Spring—contains an unfamiliar bill or two, for the Salt Spring dollar is alive and well. The Salt Spring Monetary Foundation got the alternative currency moving with the new millennium and now offers bills in several denominations between $1 and $100. The attractively designed bills display pictures by local artists of the stature of Robert Bateman and Carol Evans, and almost every merchant on Salt Spring, including the banks, regards them as legal tender.

## Books Galore

Sabine Swierenga bought the contents of a bookstore in Vancouver and moved 15,000 volumes to Salt Spring in 24 hours. This collection was the foundation of Sabine's Fine Used Books, the Gulf Islands' premier used bookstore. Two floors of intriguing volumes, shelved among attractive furniture and plants, greet the browser.

Many book lovers have wondered about a connection between the store's name and Nick Bantock's *Griffin and Sabine* series of books. The answer is a little complex: there wasn't a connection at first but there is now. When Bantock moved to Salt Spring, he and the bookstore proprietress became acquainted. There is now a Gryphon room—also called the Griffin room—upstairs in the store featuring Bantock's books and prints, where he visits from time to time as author-in-residence.

Ganges also has three fine new bookshops, and each of the other

larger islands have at least one bookstore, often combining new and used books. Galiano Island Books, Miners Bay Books on Mayne and Talisman Books and Gallery on Pender are all well-established bookstores with a wide selection of local information and books by local authors, in addition to more general stock. My search for island information has taught me to also check other outlets including galleries, grocery stores, marinas and resorts.

### Let's Buy the Island

"How the devil did we get here?" The question bothered David Conover one morning in the 1960s, when he and his wife Jeanne had already lived on Wallace Island for 20 years. His answers, recorded in his 1967 book *Once upon an Island*, involved a trip from his boyhood home to be a camp counsellor on Wallace in his college days; military service in Pearl Harbor; photographic work during which he discovered a young factory worker and encouraged her to become a model (she was later known as Marilyn Monroe); and a postwar trip that led them to buy Wallace.

The young couple built and rented cabins to make a living. They had to raft materials over from Salt Spring and struggle with unfamiliar problems of boating and boilers, plumbing and privies. They had to buy other islands and sell the timber to make a financial success of their venture. Eventually they sold lots on their island, some to former guests.

David Conover lived on Wallace until his death in 1983, but his succession of wives found island life harder to manage. The province bought most of his island in 1990 for a marine park.

Conover wrote an island classic, though, a simple tale of a young couple struggling against the odds to make their dream work, and his book has been translated into at least seven languages. It has a place on many island bookshelves and from time to time finds its way back into print to inspire new islanders.

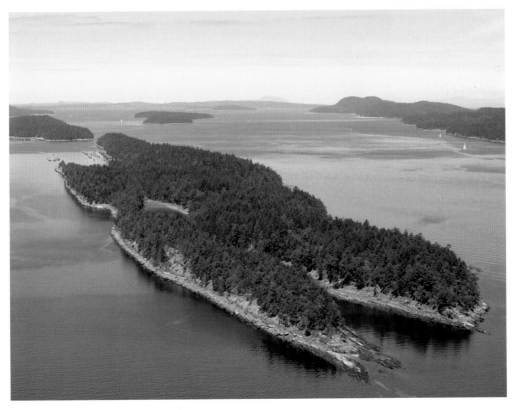

*Wallace Island, the dream home of writer David Conover, is now a park.*

8 | The Middle Islands: Out of the Mainstream

*Previous pages: Fantastic sandstone formations at Pilkey Point, Thetis Island.*

*Opposite: North Cove and Pilkey Point, Thetis Island, with Valdes and the Coast Mountains beyond.*

*Most of the Middle Islands are without ferry service; Mudge Islanders sometimes row home.*

The British Navy surveyed Gulf Islands waters, and although their activities were generally peaceful, they never knew when they'd be off to the far side of the world to join a war, so they had to keep their hands in as fighting men. From time to time they bombarded convenient cliffs with their cannon, especially along Navy Channel between Mayne and Pender. Gerry Payne on Saturna used to grumble when the cannon fire disturbed his sheep during lambing season, but otherwise there were few complaints.

North of Salt Spring, between Vancouver Island and the Outer Islands, lie a number of Gulf Islands that are not well known to the average tourist. Like North and South Pender, Kuper and Thetis are halves of a single island—or are twin islands—depending on how you view them. A ferry based at Chemainus serves the islands. Until 1905 mud flats filled Canoe Pass, the canal that separates them; it leads to Telegraph Harbour on Thetis Island, which houses two popular marinas.

Thetis, six kilometres (3.7 miles) by three kilometres (1.9 miles), is the only visitor-oriented Middle Island, with a variety of accommodation and a number of church camps. Its population was 372 in the 2006 census, and it has extensive public shoreline but no parks. Kuper at 8.7 square kilometres (3.3 square miles) is primarily a reserve for about 185 members of the Penelakut First Nation.

Short strings of smaller islands lie between these and the Outer Islands. The Secretary Islands lie off Kuper north of Wallace Island, while Reid and Half islands lie farther east, blocking the sailor's direct route from the Canoe Pass marinas to Porlier Pass. Farther north still, the De Courcy Group leads from Pylades to Mudge, which fits in the end of Northumberland Channel between Gabriola and Vancouver Island like the stopper in a bottle.

None of these islands has ferry service, apart from Kuper and Thetis, and even these

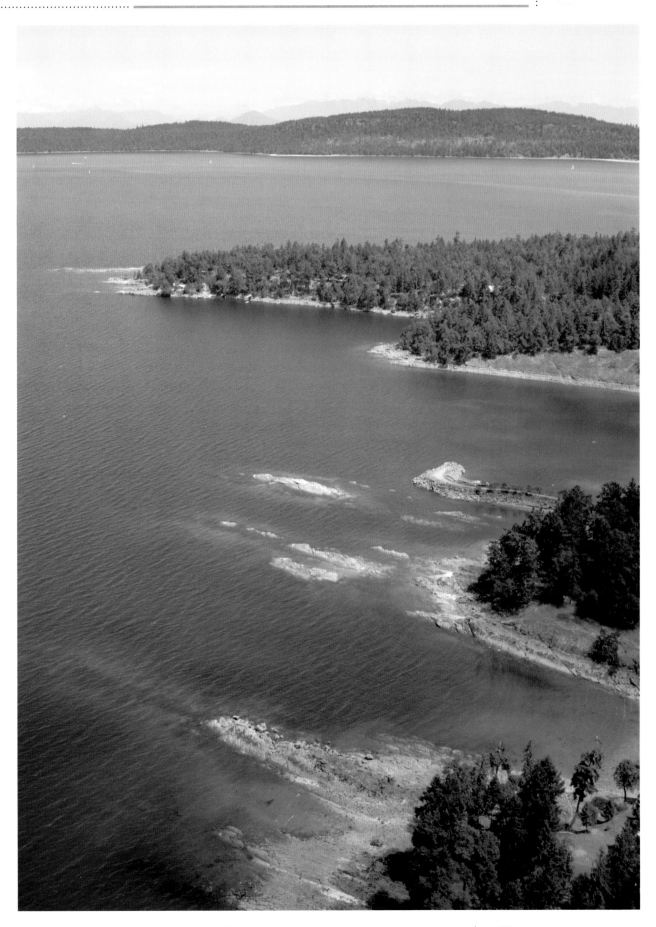

*Wings and paddles are both indispensable to Thetis Islanders.*

are not linked directly to other Gulf Islands. Middle Islands residents use their own boats or water taxis, and most tourist traffic arrives on boats that anchor in the marine parks on Wallace and De Courcy or tie up in the marinas on Thetis and Gabriola.

These relatively small islands, out of the mainstream of even Gulf Islands life, attract people who want to be alone or at least out of society for a time. Yet their stories, like those of the Inner Islands farther south, are some of the most dramatic in the Gulf Islands: stories of religious fanatics, buried treasure, a hated residential school, once even a naval bombardment.

## Send a Gunboat?

On April 25, 1863, the Royal Navy gunboat *Forward* opened fire on a Native village at Lemalchi Bay, Kuper Island.

The *Forward* was commanded by a lieutenant, the Hon. Horace Douglas Lascelles, seventh son of the third Earl of Harewood. The wooden three-master of 32 metres (105 feet) was powered by 60-horsepower engines to back up its sails and carried a 68-pound (30-kilogram) gun on its forecastle, a 28-pound (13-kilogram) gun aft and two 24-pound (11-kilogram) howitzers amidships. Armour protected the gun crews. The Lemalchi people took cover with an assortment of firearms in a log house with loopholes.

The specific reason advanced for the attack on Kuper was a murder on Saturna, where

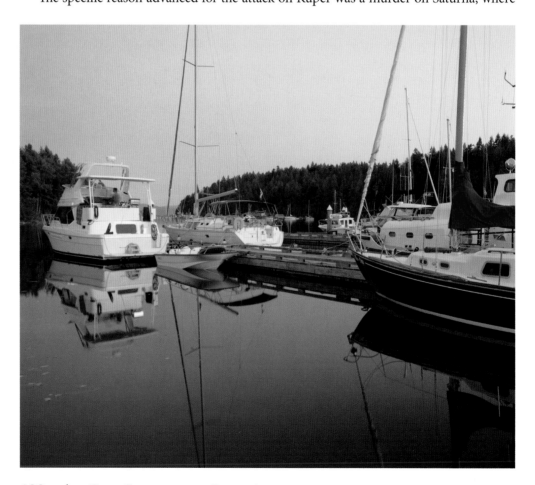

*A busy marina in Telegraph Harbour, Thetis.*

Frederick Marks and his married daughter, Caroline Harvey, had been killed on their way to Mayne Island. At that time the islands had no police; British naval vessels sent around the Horn to the West Coast provided the only law enforcement. The skipper of the *Forward* believed that the Kuper Island village sheltered some of the perpetrators, though surviving First Nations versions of the story deny the accusation. The official records indicate that the navy threatened to fire if the chief refused to come aboard to deliver the miscreants.

When the navy opened fire, the villagers promptly left the blockhouse, gathered at points opposite the stem and stern of the ship and raked it with gunfire. The ship took no damage but lost a boy, Charles Gliddon, who was supplying the gun with powder. Official records list no Lemalchi casualties, but the *Forward* destroyed the village and the villagers fled across the border. A landing party found no weapons of mass destruction.

After a century and a half, it is hard to come up with a clear understanding of these events. It is clear that many legal, political and language problems surrounded this action. While the supposed perpetrators of the murder were in due course arrested and executed, there is no evidence that they were on Kuper or that the attack on the village had any bearing on the outcome. At the time most people saw this as a legitimate police action; in another view, Salt Spring author Chris Arnett suggested that it was "use of armed force to end [Native] opposition to the occupation of their lands by [whites]."

The island had been named after Captain Kuper of the *Thetis* in 1859. In one of history's little ironies, the month before the bombardment of his namesake island, the by now Admiral Kuper threatened to destroy Yokohama, Japan, after the murder of an English traveller. Rather than see their city destroyed, the citizens of Yokohama provided an indemnity worth £100,000.

*A solitary juniper crowns Pilkey Point, at the northern tip of Thetis Island.*

*At the residential school on Kuper, First Nations children were drilled in European culture.* British Columbia Archives, F-01277

### A Reserve and a School

The people of Lemalchi Bay did not rebuild their village and moved to join the Penelakut, a group that used to specialize in hunting sea lions, on the other side of the island. In 1864 two settlers were refused permission to settle on the site of the old village, but one "fell in love with the chief's daughter" and lived there anyway. The village was partly rebuilt, but the original site was pre-empted and then purchased for an Anglican mission. The rest of the island became a reserve.

In 1890 a government residential school was built on Kuper and run by a Catholic mission. At first it accepted a variety of students from the region; some of Portuguese Joe Silvey's grandchildren from Reid attended from 1897. The students learned literacy and practical skills, but were allowed only two visits home during the year. Some time after World War I the school took only First Nations students with treaty status from around the region. *No Time to Say Goodbye* (2002), a novel written by Sylvia Olsen in conjunction with Rita Morris and Ann Sam, deals in fictional terms with some of the experiences of six children who attended the school in the 1950s. They were forbidden to speak their language or practise their culture, which she said "left many deep and lasting scars on First Nations individuals, families and communities."

The school, closed in 1975 and demolished a decade later, is now the site of an adult learning centre. A 1997 film, *Kuper Island: Return to the Healing Circle*, shows former students who gathered in a remembrance and threw flowers into the water in memory of students who had drowned trying to escape.

## Boss and Madam

Camping overnight in Preedy Harbour on Thetis around 1890, the Burchells decided to stay. They bought a partly cleared farm and proceeded to dig in, helped by a group of Chinese labourers who had worked on the CPR. Their workers called them Boss and Madam, and everyone adopted the nicknames. The Burchells seem to have been taken in by a con man who brought them to Kamloops and abandoned them there, and, despite their wealthy British background, they had run short of money. Henry wrote to his old headmaster and offered to train young men in agriculture, and with their help he logged, operated a sawmill, farmed and built a barn and an elaborate house that later included a chapel.

A summer sunset casts its spell over Thetis Island waters.

Helen, the daughter of an admiral, had been presented as a debutante to Queen Victoria. On Thetis she started a store and learned Chinook Jargon so that she could speak to her First Nations customers. Her store was one of the last to take Hudson's Bay blankets as currency, and she supplied many items needed for distribution at potlatches. She was hostess of many bridge parties and Christmas dinners where the guests included the Saturna Paynes.

Helen's sister Geraldine Hoffmann and her son Rupert set off from England on a round-the-world tour in 1907, stopping off at Thetis to visit her family. They too decided to stay. After the war they ran an extensive poultry farm staffed by young men with an "English public school education" and raised a third generation of this remarkable family.

### Playing the Islands

David Essig, one of many well-known performers living on the Gulf Islands, is a musician's musician. I have been privileged to watch David at work in many contexts: rehearsing in his Thetis home (which he does every day he can), playing house concerts, teaching guitar workshops in my basement on Pender and recording students in a songwriters' camp. It is always fascinating to watch him at work—finger-picking through "I'll Fly Away" as he leads a gospel performance, flying off into a wild improvisation at the end of a methodical workshop or standing barefoot in a camp dormitory to gently coax the best from a never-recorded-before songwriter who is playing in a nest of mattresses piled up to damp the reverb—after which David sits down during the play-backs with his Weissenborn guitar across his knee to improvise a possible countermelody.

*Celebrated guitarist David Essig once served as chair of the Islands Trust.*

Born in Maryland, David was reared in bluegrass and blues, and has a command of the guitar and its relatives that few players share. He began playing at 16 but studied public policy and economics for a while, then moved to Canada in 1971 where the "talented newcomer" became a full-time musician. David has been a Canadian since 1978 and has lived on Thetis and Protection with his partner Milena, who teaches at Malaspina College.

He has recorded some 20 albums of traditional material and his own dramatic songs. David moved from vinyl to CD in 1982. He set up one of the first musician-run recording companies, and has produced many albums for other musicians, hosted shows for CBC and toured many times in Italy, Germany and Australia. In 1982 he went to Korea to study the 12-string *kayagum*, on which he has also recorded. On the road David stuffs his acoustic and electric guitars and an incredibly compact recording studio in his Mini Cooper.

## Portuguese Joe

Joseph Silvey was in his fifties when he pre-empted 65 hectares (160 acres) of Reid Island in 1881 and moved there with his second wife and four children. Thanks to Jean Barman's careful research, we can look at Joe as a representative of the many early islanders who lingered on the fringes of history, living adventurous lives, appearing occasionally in government records and other people's memoirs, but themselves illiterate and thus leaving no records other than the houses they built and the memories of their descendants.

Joe was born about 1828 in the Azores, a group of Portuguese islands in the mid-Atlantic. His name has been recorded as Silva, Silver, Silvey and Silvy; other Silveys lived in British Columbia and Portuguese Joe or Portugee Joe was a common nickname. As a child he took part in the whaling trade, and like many Azoreans he signed on a whaling ship and ended up in the Pacific. He jumped ship about 1860, perhaps in Victoria, and took part in the Fraser River gold rush. Soon afterward he married Khaltinaht, the teenage granddaughter of Musqueam chief Kiapilano, making all the arrangements by sign language.

In 1866 Joe was fishing in Active Pass, catching fish for sale and dogfish to extract oil to lubricate sawmills. He took citizenship in 1867 and applied for land at Mary Anne Point—named after Khaltinaht who had now acquired an English name—on Galiano. Later the growing family lived at Burrard Inlet, went whaling from Bowen Island and lived in Gastown, where Joe ran a saloon. There Mary Anne died, leaving Joe with two young daughters.

A new marriage—this time in the Catholic church—in 1872 made Kwahama Kwatleematt (Lucy) a stepmother to the girls. Joe had a house on the mainland but fished around the Strait of Georgia and through the Gulf Islands, up to Nanaimo and Newcastle Island and along the Sunshine Coast. He pioneered seine fishing in British Columbia, taught the First Nations women to make nets and caught salmon for the earliest cannery. But the Vancouver area was getting too busy for working fishermen, and he may have found the growing population less tolerant of mixed-ancestry families, so he moved his family to Reid.

Joe built a new house, planted an orchard, ran a store for passing marine traffic, fished

the local waters and took seven new additions to his family over to Kuper for baptism at the Catholic mission. Within a few years his oldest daughter was married and living on Thetis, while his eldest son, Domingo, owned land on Reid beside his father and continued to help with the fishing. Joe supplied the Penelakut nation on Kuper with fish and received venison in return.

Joe's family could communicate with their many visitors as needed by speaking Portuguese, English, Cowichan or Chinook Jargon. He eventually died in 1902 and was buried on Reid Island. The sons and daughters married, often into other mixed-blood families, and stayed on Reid, settled on other islands in the vicinity or went back to the mainland.

## Brother XII and Madame Zee

In October 1928, Edward Arthur Wilson appeared in court in Nanaimo, accused of stealing money from his own creation, the Aquarian Foundation. Although he was acquitted, the appearance began the unravelling of Wilson's bizarre career.

Born in 1878 in Birmingham, England, Wilson went to sea and then settled in British Columbia. After reported mystical experiences he renamed himself Brother XII and set up the Aquarian Foundation, a mystical cult with elements of Ancient Egyptian religion, astrology, Buddhism and theosophy. As his followers increased to some 8,000 around the world, he established a colony in 1927 at Cedar, south of Nanaimo. Disciples from around the world travelled there, bringing all their funds in gold coin to support his mystical work.

His followers found Wilson's regime harsh; he separated couples and expected members to do manual labour on the colonies as a spiritual test and in fear of Wilson's supposed magical powers. He subjected some to sadistic treatment. He later faced accusations of sexual misconduct with some of the wives, but claimed that a future child would be a sacred being who would succeed Wilson as leader. Wilson appointed one woman, who became known as Madame Zee, as foreman of the colony. (She is now the subject of a novel by Salt Spring writer Pearl Luke.)

Brother XII expanded his domain to part of Valdes in 1928 and persuaded a supporter to acquire De Courcy and Ruxton Islands in 1929. He renovated a farm and built his own residence on De Courcy and moved there with Madame Zee.

Some of his followers became restless and deserted the colony, and after the court case the government took an interest in the affairs of the Aquarian Foundation. Brother XII and Madame Zee changed their names again, both taking the surname de Valdes. Trusted followers helped to hide large sums of money in American gold coin, purchase rifles and build forts around Wilson's headquarters. By the time a court case against Wilson succeeded in 1933, the couple had left De Courcy, damaging everything they left behind. They wandered through British Columbia for a few months, moved to England and were last heard of in Switzerland. Wilson is supposed to have died there, but there are also reports that people saw him and Madame Zee afterward in various places. The reputed gold has never surfaced. Some believe it is in a Swiss bank account, while others believe it is still hidden on De Courcy.

Under his own name Edward Arthur Wilson is a forgotten figure, but as Brother XII he has entered into legend.

# 9 Gabriola: Petroglyphs and Millstones

**Previous pages:** *Malaspina Gallery's "frozen wave" on the north end of Gabriola was the islands' first tourist attraction.*

Malcolm Lowry called his 1970 novel *October Ferry to Gabriola,* but for some of my friends a November ferry from Gabriola is what they remember. Twenty-odd years ago, they had headed for the ferry from their Gabriola home at high speed. Gerry was concerned enough to get the doctor and the ambulance, though Kathy was sure she was in no hurry. Their unborn baby agreed with Dad, making an abrupt debut around the middle of the 20-minute crossing. By the time the ambulance rolled off the *Quinitsa* at the other end, it was all over. A few weeks later the ferry captain presented the proud parents with a plaque documenting the unusual birthplace and a card granting baby John free passage for life between Gabriola and Nanaimo. But don't expect to run into John on the ferry anytime soon. With this useful gift in his pocket John moved to the prairies as soon as he grew up, and when I checked the details of this story, he and his wife were on their way to Belize for a year.

Gabriola is the most northerly of the larger Southern Gulf Islands, though a scattering of smaller islands, of which Newcastle is the largest, lies just across the harbour from Nanaimo. Gabriola forms a fat crescent, with the slightly hollow side toward the northeast; the shores on the long sides are almost unindented, with small bays at each end. Settlement generally occurs on the lower ground along the shores, and most services cluster at the northern end near the ferry terminal in Descanso Bay. Forests cover most of the higher ridges in the central area, now increasingly set aside as parkland.

A long First Nations presence is evident from the many petroglyphs and ancient village sites formerly used by the Snuneymuxw, such as the False Narrows village site that is over 2,000 years old. Spanish captains Dionisio Alcalá Galiano and José María Narváez visited in 1791. Miners from Nanaimo—primarily Scots and Irish—were the first newcomers to settle on the island in the 1850s; others who followed included Chinese and Portuguese, and settlement has kept pace with the nearby city's growth, so the population is now 4,050. With a 20-minute ferry ride and a shopping mall just across the road from the Nanaimo ferry dock, Gabriola residents have easy access to the city, and many commute to

*Gabriola Gertie, created by Bob and Dee Lauder, greets visitors at the Gabriola ferry terminal in Nanaimo.*

*It's expensive to tow island clunkers away when they die, but they can always be put to decorative use.*

The Quinsam *heads for Gabriola with a heavy load of residents and tourists.*

*A constellation of sea stars on Gabriola.*

work or shop. The island can be either a suburb or a getaway, at your pleasure.

Tourists flock to Gabriola's attractive beaches and parks. Community parks and nature reserves in the centre of the island supplement Descanso Bay and Gabriola Sands near the ferry, Sandwell in the north, and Petroglyph Park and Drumbeg Park in the southeast.

## *Faces Peering from the Past*

One of the most unusual—and fascinating—birthday gifts I ever received from my wife, Andrea, was a guided tour of some of Gabriola's many petroglyphs, which gave me a strong feeling for these fascinating images of the past. Dedicated research over several decades by Mary and Ted Bentley, which has revealed most of the known petroglyphs, made this possible. In their book *Gabriola: Petroglyph Island*, they described how they "rolled back the spongy, wet moss like a thick green quilt. A deeply carved double eye and head plume of an elaborate petroglyph lay exposed on the glistening bedrock." It was 1976, and the Bentleys had found the first of many lost images near the United Church on South Road.

Petroglyphs are patterns of lines incised into rock to make an image. People have found many on the west coast of North America, but they're usually known only to locals. A compilation of regional data published in 1974 shows only two on Gabriola; when the Bentleys started their search, they knew of five. Now the Bentleys and others have documented between 80 and 100 on this island alone.

When I revisited the church site, I found the narrow trail that leads through the forest as I remembered; the sunny open patches reveal gently rolling areas of bare rock partly covered by low vegetation. Many of the petroglyphs are as I remember them. Some portray people and recognizable animals, but others are more subtle, perhaps showing eyes or

*Dozens of petroglyphs have been found at the "church site" on Gabriola.*

mythical creatures. Weldwood, the forestry company that owned the site near the church, generously donated six hectares (15 acres) for their protection. You can see some of the finest examples there, though they are suffering from wear and erosion, people's occasional well-meant attempts to chalk in the lines for photographs and sometimes the less-well-meant and illegal efforts of modern petroglyph makers.

Very few stories suggest a context for such carvings. Hudson's Bay Company employees watched an artist carve a petroglyph at Fort Rupert to mark a ceremonial occasion sometime between 1849 and 1882. Archeologists have used carbon-14 from undisturbed overlying beds to date a petroglyph on Protection Island to about 1600. Many people have asked First Nations for explanations. Some did not know (or chose not to say), while others suggested they date from the time "before animals were turned into men." Anthropologists associate them with vision quests and sacred places, a view echoed by some present-day aboriginal people who say the images are sacred.

Another question remains. Why does Gabriola have so many petroglyphs when only a few examples are known on other Gulf Islands such as Salt Spring, Mayne, Galiano and Thetis? Did the horizontal sandstone beds offer a canvas for ancient artists, or was the island a specially sacred place? Or are they just as common on other islands, where we've lost track of key sites, as happened on Gabriola for many years?

As they become known, interest in the images increases. The Snuneymuxw have trademarked 10 of the images to prevent sacred designs being used for commercial purposes. In co-operation, the island uses one image to represent the Dancing Man Folk Festival, and the Gabriola Museum has created copies of others for Petroglyph Park in its grounds to let visitors make their own rubbings without damaging the originals.

*Entrance Island's lighthouse was constructed in 1875 to guide ships into Nanaimo's busy harbour.*

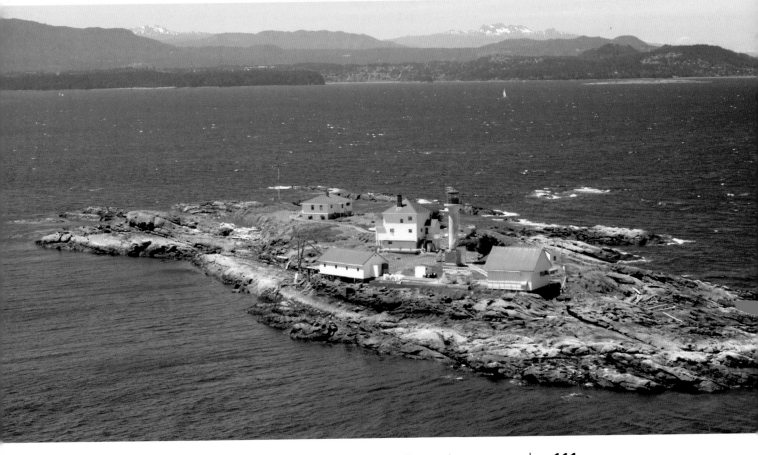

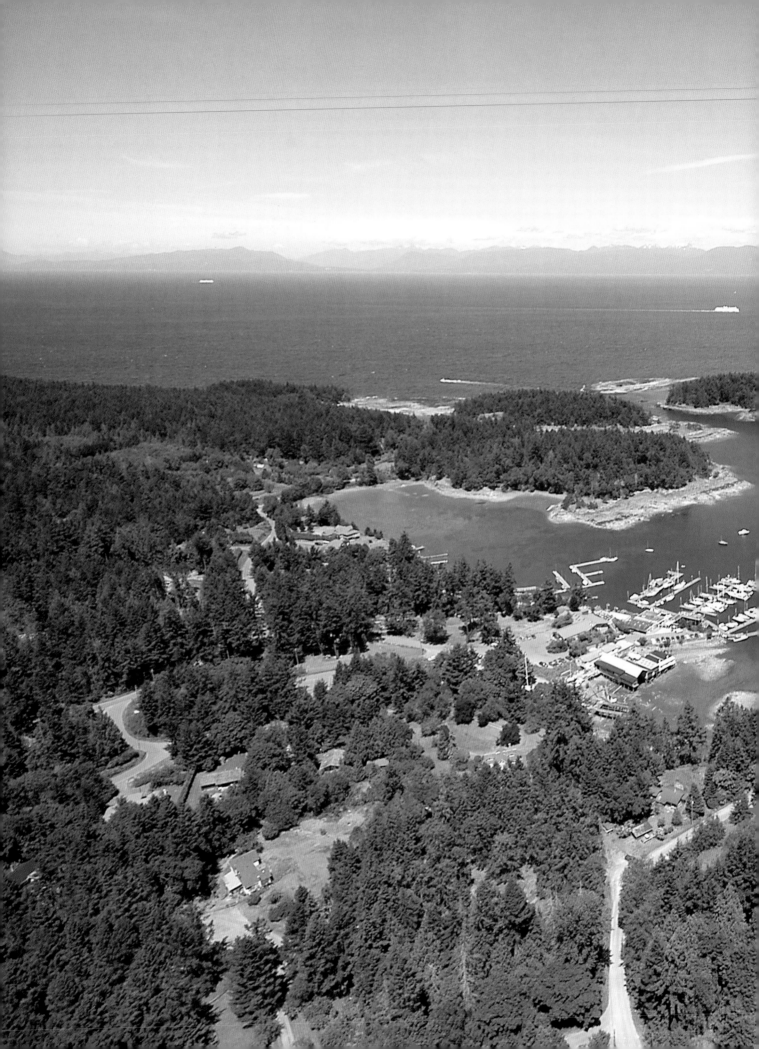

*The Flat Top Islands shelter
Silva Bay and its marinas.*

## *Malaspina Gallery*

A quite different Gabriola tourist attraction has been known in Europe for more than two centuries. Alcalá Galiano and Valdés sailed to Gabriola in 1792 and devoted six pages to the island in the account of their journey published in 1802, with portraits of two Native chiefs by artist José Cardero. It seems likely that the same artist drew a picture of what was called the Galiano Gallery, eventually redrawn in a report of Alejandro Malaspina's voyages, published in 1885 in Spain.

Today you can find the Malaspina Gallery, as we now call the Galiano Gallery, on the south side of Malaspina Point on the north shore of Descanso Bay, where the ferry docks.

If you haven't seen the gallery, imagine a roughly cylindrical cave four metres (13 feet) high and extending for 75 metres (246 feet). One side is missing, and the floor is close to sea level, so that waves lap your feet at high tide. The more poetical observers compare it to a frozen wave, but in fact the gallery is a deep notch that waves eroded into soft sandstone between harder layers, back when the sea level was a metre (3.3 feet) or so higher than it is today. Interesting erosion patterns that decorate the rock faces have been part of the attraction—appealing to many artists such as E.J. Hughes—and brought many tourists to see this interesting rock formation.

Since the gallery has been known for centuries, it is entertaining to learn that it was "lost" early in the 20th century—lost at least by Professor George Davidson, sometime of the United States Coast and Geodetic Survey and the University of California, who studied early West Coast place names. In 1903 the *Victoria Daily Colonist* and the *Nanaimo Free Press* reported on his efforts to locate the missing gallery. It was also lost by the Geographical Board of Canada, whose Gazetteer Map marked the gallery on the northeast side of Malaspina Point in all three editions!

Fortunately the gallery was still where it had been for millennia, as a resurvey by Commander Parry of the *Egeria* shows in the British Admiralty map published in 1905. In case it had moved while no one was looking, the Geographical Board confirmed its position again in 1970.

*The old millstone quarry is evidence of Gabriola's industrial past.*

## *Coal and Millstones*

Che-wech-i-kan, a Snuneymuxw man from the area we now know as Nanaimo, visited the Hudson's Bay Company blacksmith's shop in Fort Victoria in 1850 and recognized the black stones the blacksmith was burning in his fire. When he came back with a canoe full of the black stones, the company sent clerk Joseph McKay to investigate. (His daughter Lilias later married Arthur Spalding of South Pender Island.) McKay found coal seams on the shore near the site of the future Hudson's Bay Company bastion and on nearby Newcastle Island.

Mines soon stretched beneath Newcastle Island, named for the industrial city in England from which some of the miners came. The island also had a fish saltery, a cannery, a shipbuilding and repair shop, and a quarry that supplied stone for the San Francisco mint.

Miners soon settled on Gabriola and were quick to recognize other resources. A quarry, opened near Descanso Bay in 1887, shipped sandstone to Victoria for use in a number of buildings including the old post office. In 1932 industry found a new use for the hard stone.

*Monique, the wooden hitchhiker, greets boaters arriving at Page's Resort & Marina in Silva Bay.*

A special saw cut out millstones a metre (3.3 feet) or more in diameter. Each weighed several tonnes and was worth some $600; the island shipped more than a thousand to mills as far away as Finland to mash trees into pulp to make paper. You can still see a few stones on the island, and one section of the quarry with its rows of circular holes is protected as a nature reserve. Gabriola also had a substantial brickyard, which a staff of Chinese workers ran from 1895 for half a century.

Today's islanders may be forgiven if they are unaware of the extensive industrial history around them, as few traces are visible. But the islands were accessible to industry as well as agriculture, and newcomers exploited commercially viable resources with energy and enthusiasm. Other brickyards were at Bricky Bay on North Pender, where waste bricks still litter the shore, and on Sidney Island. Saturna's Lamb Barbecue takes place in a quarry and plant where BC Lightweight Aggregates produced road material into the 1960s. Other commercial plants operated on almost every island.

Place names, old photographs and the memories of old-timers point to less obvious industrial locations. Whaler Bay on Galiano reminds us of once active whaling in the area, and a few timbers are all that remain of the Shingle Bay fish reducing plant on North Pender. Everywhere, old tree stumps show the holes for the logger's springboards, as all the islands were stripped of merchantable timber. Few traces remain of other activities, such as the 1890s coal mine on Tumbo or more recent drilling for oil on Saturna.

## *Mostly Marinas*

I don't own a boat any more, since the rowboat sank and someone stole the canoe. But I still love marinas, where I can wander along the docks with other dryland sailors and gander at other people's boats. Marinas play a vital role as the interface between land and water traffic. Island boat people need somewhere to keep the powerboat or sailboat that they have dreamed of for so many years in the city. There they can carry out the messing about in

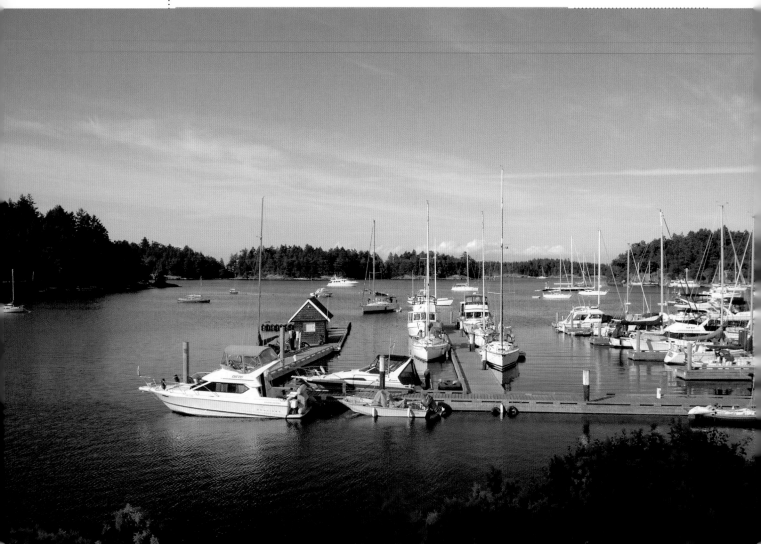

*Silva Bay Marina and Resort houses a wooden boat building school.*

boats that still seems to be an essential part of the boater's life, filling in time between those dramatic voyages to the other side of the world, the round-the-island race or the voyage to the nearest pub to splice the main brace and talk about the last (or the next) voyage. Visiting boaters from nearby cities or around the world also need somewhere to moor and refuel boats, bodies and minds. Sheltered spots around the islands harbour docks, fuel pumps, stores, cafés and pubs.

The south end of Gabriola has an ideal refuge in Silva Bay, where a number of little bays house three marinas sheltered by the Flat Top Islands. John Silva had jumped ship with Portuguese Joe Silvey of Reid Island. With his Cowichan wife, Louisa, Silva came to Gabriola from Mayne Island in 1883 to escape Haida raiding parties and bought about 54 hectares (133 acres) around the bay. The Silvas left their name on the map and sold off sections of land as they got older.

Two Japanese families, the Haminakas and the Koyamas, ran a fish camp and store on floats in the bay by from the 1930s until they were moved to the Interior during the war. The Page brothers, Jack and Les, had grown up on Galiano and operated a fish buying camp at Otter Bay on North Pender before they bought land in Silva Bay in 1943. The brothers opened the Page Bros. Store and Fish Camp, where they bought and sold fish and fuelled fishing boats; gradually their camp became a base for vacationers from the mainland.

In 1987 Ted and Phyllis Reeve bought Page's Resort and Marina but retained the historic name. The new owners developed a cultural component to their operation by selling numerous books by regional writers, hanging art exhibits and holding literary and musical events at the Sandstone Studio in their house. They commissioned sculptures from Bob and Dee Lauder, of Fogo Folk Art; arriving boaters meet Monique, the hitchhiking dolly on the dock, and can check in with life-sized sculptures of their hosts on perpetual duty in the office and store, even now that they have retired in favour of daughter Gloria and her husband, Ken Hatfield. Two other marinas share the bay, adding a restaurant and motel to the available facilities. Silva Bay also houses the Silva Bay Shipyard School, advertised as Canada's only full-time traditional wooden boat building school.

## *Mermaids and Ogres in Taylor Bay*

Sea, sun, sand—and dozens of kids and adults working hard on their vacations. That's the general picture at Taylor Bay's 10th Annual Gabriola Sand Festival.

Back in 1997 Jordan Sorrenti was a Gabriola visitor, looking for something to keep his kids amused. With his friend Doug Harle, a former sand castle champion, he came up with the idea. Doug arranged for a few demos of creative sand art from his former team members, and 20 teams entered the first competition. Now the sand festival is a fixture, scheduled for two hours on a suitable tide sometime in the first two weeks of August.

Then organizers mark out squares in the sand at the head of Taylor Bay and provide a huge water container; teams bring their ideas, traditional buckets and spades, garden tools and plywood forms. After they check in with the judges, their challenge is to make creative use of a square of sand and whatever shells, seaweed and other debris they can find on the beach. It is fascinating to wander around watching as competitors gather resources, dig holes, and mound up and shape heaps of sand.

At first, it is not easy to tell what the builders are planning as they work away with intense concentration. Then shapes begin to emerge: a giant octopus, a garden of historic lighthouses, a tractor in relief. A giant face enjoys the sun, a dog dozes besides a rock pool filled with sea stars and crabs, an ogre clambers out of the ground, a giant hand clutches an apple. Sand dollars suggest the plates of a turtle, and the tractor plows a seaweed field. Sometimes diggers themselves become part of their creations; a mermaid's tail is constructed around the legs of a patient young girl, and a young man has apparently lost a leg to a sandy shark.

Jordan is still the festival organizer, but now he lives on the island, runs a coffee shop and co-publishes the *Gabriola Sounder*. He is one of the red-shirted judges walking around and making notes as the tide creeps in and the builders reach a new intensity. Four winners triumph in the kids and families categories. The trophies are engraved buckets, handed out along with other prizes donated by local businesses. After all this excitement, the tide washes away the ephemeral figures while people picnic, swim and doze, dreaming no doubt of a bigger and better construction for next year.

*Taylor Bay is the scene of Gabriola's annual Sand Festival.*

10

Island Fun,
Island Futures

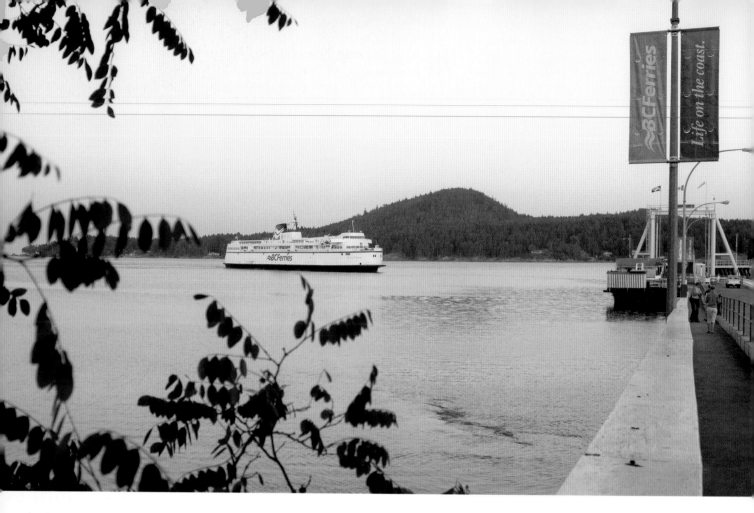

*A ferry approaches Sturdies Bay, with Mayne's Hall Hill behind.*

*Previous pages: Sunset view from Cabbage Island; a favourite camping spot.*

## Getting to the Gulf Islands

All the major islands are served by BC Ferries which carry vehicles, foot passengers, cycles and kayaks. In general the ferries connect Salt Spring, Pender, Mayne and Galiano to Swartz Bay on Vancouver Island and to Tsawwassen on the mainland, while Saturna traffic often has to transfer at Mayne. Other ferries connect Salt Spring to Crofton, Thetis and Kuper to Chemainus and Gabriola to Nanaimo. Only the ferries out of Tsawwassen can be pre-booked. More northerly islands are served from Vancouver Island ports as far up as Nanaimo.

Planning your trip is an art; experienced islanders check the timetable or website twice—identifying transfers and making sure there are no special arrangements for public holidays or experimental changes that aren't in the printed timetable—before deciding how and when to travel. Summer trips at peak periods may be fully booked or overloaded before you arrive, while winter runs may be delayed by bad weather. Or you may find that the large ferry you are expecting has gone for refit, and the smaller replacement fills quickly. Once you learn the routine, you'll find most ferry trips enjoyable, or at least relatively painless, but islanders are prepared for occasional delays or disruptions of service.

Small private ferries serve Sidney Island from Sidney (summer only) and Newcastle Island and Protection Island from Nanaimo. To all other islands you'll need to travel by hired water taxi, your own boat or a rented boat, wind and weather permitting. If you take a boat, you may need to book a marina or dock berth in advance.

Several small airlines provide air service for those who don't need to take a vehicle, flying float planes from Seattle and Vancouver to Pender and Salt Spring, with stops at islands in between by arrangement—always fun as you never know exactly where you will be going. It is a good idea to pre-book and leave surplus luggage behind.

## A Camper or a Pampered Guest?

You can find almost every kind of accommodation somewhere on the Gulf Islands—but not on every island all the time. In high season it's wise to secure your preferred accommodation in advance; it's not a good idea to start looking after the last ferry has left.

Many part-time islanders have their own self-catering cottage, from an old shack in the woods to a time-share at a resort or marina.

If you have to find accommodation, the cheapest is camping. Campsites are available at some parks and marinas, but beware—not every island has a campsite. These vary from walk-in to RV-accessible, and it's advisable to book ahead.

Bed and breakfasts abound on some islands, from simple to luxurious, but usually at the higher end. Expect good food and local knowledge from interesting hosts.

Hotels, resorts and inns are fewer and range from mom-and-pop motels to more pretentious—or even internationally famous—establishments such as Hastings House on Salt Spring.

In addition to these usual types of accommodation, houses on the islands may be available for family friends or for rent. The islands are currently reviewing vacation rental practice, however; some do not allow any at all, and others limit them to a minimum period of a month. Again, it is best to check with friends or rental agencies, and plan ahead.

*Loafing on the beach at Bellhouse Park on Galiano.*

*Hastings House is a renowned luxury resort and restaurant on Salt Spring.*
*Courtesy Hastings House*

## *Up the Mountain and around the Point*

"Dad was a great person to go up mountains," remembered one of Gerry Payne's daughters. "It was the thing Sunday afternoons when we were small children; we always had to climb a mountain." Even when settlers had to walk or row to get around, they would still go out for a walk or a boat trip for recreation.

On the islands, the outdoors calls through every window. Visitors and returning islanders alike seek out the nearest sea view, where islandness is most apparent. Island shorelines are endlessly fascinating; a complex pattern of beaches and bays, cliffs and crags separate the land and the water, and the tides constantly change the shape of the land and the possibilities of the shore. Beachcombing is a prime attraction. The beaches may be sandy, muddy or pebbly, but the kid in each of us can find interest in the passing scene of ships and whales, seals, otters and mink, the range of seabirds, the delightful life of tide pools and the creepy crawlies that hide under rocks.

Trails beckon the hiker and bird watcher, every quiet road suggests a bike ride and every beach access promises a beach, a tide pool or a place to launch a kayak or peek underwater. Many islanders quietly enjoy their outdoors, and visitors come specially to explore it. Many of the quieter roads make pleasant strolls, while each island offers both leisurely trails and strenuous hikes. Some trail systems are better signed and maintained than others; look for local pamphlets or websites.

A more purposeful naturalist will find lots of good bird watching year-round, particularly along seashores and lakeshores, or a delightful variety of woodland flowers or fungi in season. The same subjects appeal to the photographer, who will also enjoy lingering among the older buildings, strolling along the byways or attending lively public events such as fall

*Island trails are good for a casual stroll or a long hike.*

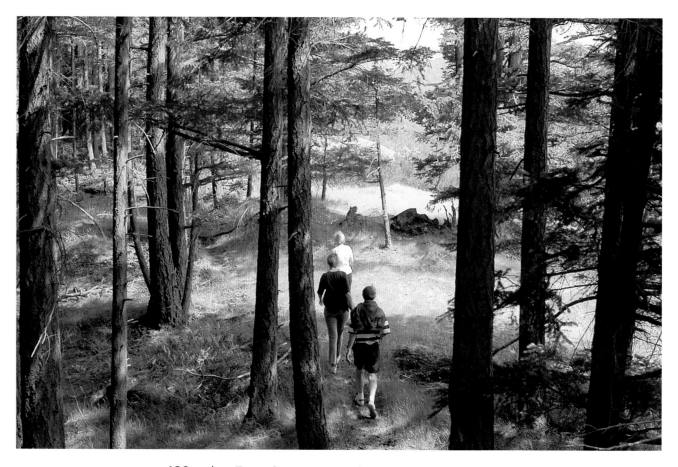

fairs and farmers' markets. There are distinct guide books to the islands for cyclists, kayakers, sailors and scuba divers, each pointing out the best spots, the easiest routes and the nicest places to go.

Those dedicated to covering the ground can often rent cycles, and sometimes scooters or cars are available. Serious cyclists come in groups, guidebooks in hand, and hasten from end to end of the islands. Every island starts at sea level and can only go up, but there is compensation in the long downhills back to the ferry. Mountain biking is allowed on a few island trails such as Galiano's.

All the islands offer more organized outdoor recreation programs and facilities for those who don't want to lug a kayak or spend every day pedalling. Parks offer guided walks, and island hiking and nature clubs welcome visitors to their field trips. On Gabriola, Galiano, Pender and Salt Spring you can find a golf course, and Pender and Salt Spring also offer disk golf. More structured programs and services are available in some places: fishing trips, kayak tours and whale watching. A few services put it all together and run art tours or eco-tours, perhaps taking in a winery or restaurant along the way.

## *In, on and under the Water*

Every New Year's Day a handful of brave souls from several islands plunge into the sea for a Polar Bear Swim. ("It was the most stupid thing I've ever done," remembers one of my daughters.) Summer swimming is possible in a few sheltered bays, but most residents and visitors prefer traditional swimming holes, like Pender's Magic Lake, or the newer pools provided by some marinas and resorts.

Boaters of all kinds find joy among the islands. The many alternative routes, varying

*The limpid waters of Cabbage Island reveal a trove of colorful shells.*

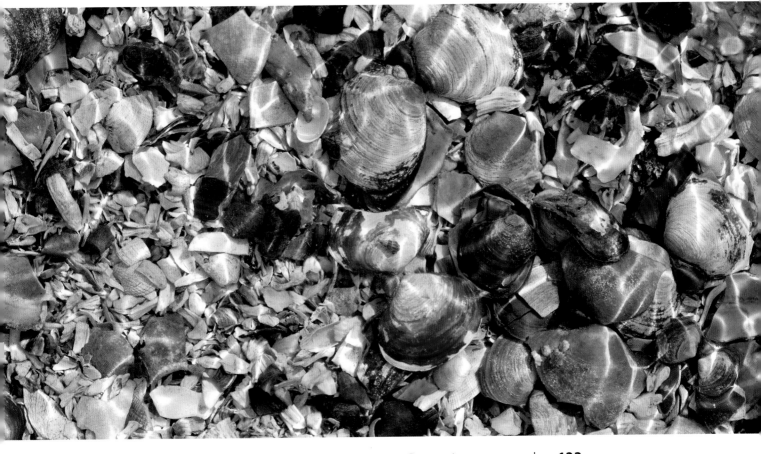

winds and changing currents offer particularly challenging sailing; I well remember a gentle trip to lunch with friends from which the return voyage was a white-knuckle ride through a 40-knot wind and four-metre (14-foot) waves. Several islands put on round-the-island races that attract sailors from distant shores. When we first moved to the islands, we had a memorable picnic in the shell of our new house overlooking Navy Channel, while almost every boat in the Pender race lay becalmed below us, drifting slowly backward in the current.

Powerboats, available for rent or by charter, are popular for sport fishing trips. Those after bigger prey can occasionally access a whale-watching trip, often run by an ecotour company, which allows visitors to catch up with some of the southern resident pods of orcas and usually see other marine mammals.

The islands have a growing reputation as a scuba destination. To divers equipped with the right gear, the surrounding waters present a great variety of marine plants and animals, including a chance to see the world's largest octopus. A number of ships—and one plane—have also been sunk as artificial reefs. Several islands, including Galiano, Pender, Salt Spring and Thetis, offer diving services.

### Blue Water Sailors

The islands are not just for local boaters, for a surprising number of long-distance sailors have been based in the islands. After finding a dugout canoe and making it seaworthy in a Galiano bay, John Voss and Norman Luxton set out in 1901 across the Pacific in *Tilikum*. The two did not get on, and Luxton left the voyage after six months. Voss reached England three years, 64,372 kilometres (40,000 miles) and 11 first mates later. Perhaps inspired by this voyage, a significant number of other islanders have put out to sea intending to find out what is really over the horizon.

*A stiff breeze off Saturna keeps sailors on their toes.*

Commander Eustace Maude of Mayne decided at the age of 77 to sail single-handed to England in 1925 in his seven-metre (23-foot) yawl the *Half Moon*. Unfortunately a swinging boom knocked Maude unconscious off California, but he refused aid and managed to struggle back to Juan de Fuca Strait alone, having travelled 6,400 kilometres (about 3,977 miles) in 97 days.

Miles and Beryl Smeeton settled on Salt Spring after World War II and lived there for nine years. In 1955, with no sailing experience, they purchased the yacht *Tzu Hang* and sailed it about 209,000 kilometres (130,000 miles) over the next 15 years.

More recently, Pender Island's Ron Palmer circumnavigated Vancouver Island in a boat he constructed himself, then sailed across the Pacific, sadly ending near New Zealand. He wrote a book about his trip called *A Hole in the Ocean*.

## Celebrating the Islands

On our first Saturday morning on Pender Island, we went to the farmers' market, which was then a few tables at the old Driftwood Centre. Among the lettuces and flowers were a couple of people selling superb reproductions of antique musical instruments. As musicians we were hooked, and in due course we added pieces to our collection. But we also became hooked on farmers' markets, and for a while after we moved to Pender we sold our own books and desserts.

The farmers' market is still a favourite place to be on Saturday morning, and we always take our guests along. We pick up favourite items from the local organic farmers, check out new products, catch up on the gossip with friends, and meet newcomers and visitors to the island. You can find fruit or choose cheese while checking out possible gifts and souvenirs among all the wonderful crafts that islanders make. There may be a few information booths as well, as conservancies, parks and other agencies take the chance to get their message out.

*Locally made condiments show up at island markets.*

*Pender musicians let it all hang out at the fall fair.*

In late summer you can find a larger scale celebration at each island's fall fair. From morning parade to evening barbecue there is a non-stop bustle, a snapshot of the entire island and its activities.

Wherever islanders gather is the place to celebrate island life. Each island has a rich mix of talented people: active professionals, amateurs having fun and everything in between. Check the local bulletin boards or island papers for information. Suitable spaces are pressed into service wherever people can find them, from Artspring—Salt Spring's dedicated theatre and gallery—to community centres, school gyms and church halls to quiet gardens. The busier islands have a continuous round of public exhibits, performances and festivals. There are art shows, concerts—of choral, classical, folk, jazz and world music—dance recitals, literary readings, storytelling and theatre. Lots of private gatherings, too, celebrate the arts and cultures of the world; we have hosted performers for house concerts, held singers' circles, sat on a beach while a group sounded eerie Tibetan bowls, attended Sacred Circles in teepees and backyards, shared writings in a restaurant and listened to a solo viola da gamba concert in a gallery.

Every island celebrates its own mix of talent, and on other islands we have enjoyed a poetry festival in a restaurant, Asian epic stories in a church and literary festivals in resorts. Islanders have wide connections with the cultural world, and performers of national and international reputation sometimes dance in school gyms or perform on church hall pianos because they happen to be visiting friends.

Special festivals take place around the year, marking seasonal milestones. Most islands have a fall fair that's a combination of harvest festival and all-purpose arts bash; some kind of Halloween celebration; and Christmas craft fairs, choral concerts and visits from the Santa Ship. More quirky and original are such local affairs as Gabriola's Dancing Man Festival, Galiano's Bob Dylan's Birthday Party, Mayne's traditional May Day, Pender's Magic Lake Lantern Festival, Salt Spring's Apple Festival and Saturna's Lamb Barbecue.

Something to take home is important for many visitors. Books about the islands or by

*On the islands, Santa arrives by boat.*

*The turn of the year is extra magical at Pender's Magic Lake Lantern Festival.*

**Opposite:** *Shearing sheep at the fall fair, Salt Spring's oldest community event.*

island writers are available in local outlets. More than 110 galleries offer glimpses into the life and work of island artists. A few are in whatever passes for downtown and carry the work of a range of artists in different media; the most comprehensive is Artcraft in Ganges, which offers work from most of the islands.

More individual are the many studios on the artists' home ground. They are open when the artist is there—"gone sailing, back in a week" is our favourite notice on a front door—and usually focus on the work of one or two individual artists or craftspeople; they may give a chance to see the artist at work. Why not chat about patina with a potter, interrogate a painter on impasto or have a yarn with a fabric artist? Residents are producing paintings, pottery, clothing and other fabric arts on most of the islands, and you'll occasionally find glass, jewellery and woodwork. More unusual items are found in only one or two places: knives on Galiano, musical instruments on Salt Spring and Thetis.

Enrich the flavour of your visit by dropping in to one of the growing number of vineyards. Salt Spring has two vineyards and a brewery; Pender, Saturna and Thetis also have established wineries. These usually offer a chance to see how the grapes are grown and processed and will certainly offer local wines.

*Frank Ducote mixes urban planning with folk art sculpture.*

### Backward Fish and Ragged Ravens

Frank bought one of Susan's prints at the farmers' market. She had given up a university job to become a full-time island painter; he was an urban planner visiting friends on the island and was exhibiting artwork in Vancouver on the side. They opened Bloodstar Gallery together in 1999, near the east end of South Pender.

Susan Taylor began as a flower painter, but she walked every day on the beach, fell for the variety of marine life, and now also paints exquisite invertebrates and dazzling fish. "Pender is a greenhouse for people," she told me. "People who come and have a dream and work out things can succeed." She got caught up in the effort to save Brooks Point and found the sense of commu-

*Salt Spring's Artcraft brings together original work from all the islands.*

nity exciting. She now sells from the gallery and through the J. Mitchell Gallery in Ganges. North Pender's Morning Bay Vineyard chose some of her more abstract paintings for wine labels, and Susan has contributed a map to *Islands in the Salish Sea: A Community Atlas* and a series of delicate drawings for *Get Your Feet Wet*, a locally produced book on intertidal life.

Frank Ducote is still an urban planner—now a freelancer consulting across the continent—but on Pender he is an artist. He liked Susan's fish paintings but didn't want to compete, so he began constructing wonderful folk sculptures of fish and birds out of driftwood and other found objects. "Our art is very different," he said, "but we both reflect the surroundings." Frank loves to paint sheep and birds; he is particularly fond of ravens and crows, which move raggedly against bright backgrounds.

When nearby Poet's Cove Resort was under construction, it commissioned the pair to produce a piece for the Aurora Dining Room. "It was a food prep area, so they wanted it washable," explained Susan. The artists experimented and came up with a technique for painting on Plexiglas. They had to do everything backward, with the highlights applied first, but they solved the technical and artistic problems, and now a glorious school of rockfish swims along the wall with attendant tubesnouts and lumpsuckers.

*Susan Taylor paints exquisite invertebrates and dazzling fish.*

## *Preserve and Protect*

"When I arrived on Pender Island in 1967, I was alarmed to learn that there were no planning rules and no municipal government to enforce them," said developer Ralph Sketch. But things were moving fast. Magic Lake was the largest of several developments on Pender Island, while MacMillan Bloedel proposed more than 1,000 lots on Galiano.

In 1970 the regional districts took over planning responsibility for the islands, and the next year asked islanders their opinions of several options for island development. Option A had bridges linking Swartz Bay to Salt Spring and the Outer Islands, with new towns on the larger islands and the Tsawwassen ferry service terminating on Galiano or replaced by another bridge. Option B offered moderate growth and some new parks. Option C had major park acquisition and limited growth in other areas. Eighty-eight percent rejected a Victoria-to-Vancouver bridge and 63 percent favoured more parks.

Jim Campbell of Saturna, chair of the Capital Regional District, encouraged the development of community plans and chaired meetings on Galiano and elsewhere. A select standing committee of the legislature was set up by the municipal affairs minister in Dave Barrett's government to "inquire into the future development of the islands."

*River otters travel island shores and feed in the sea.*

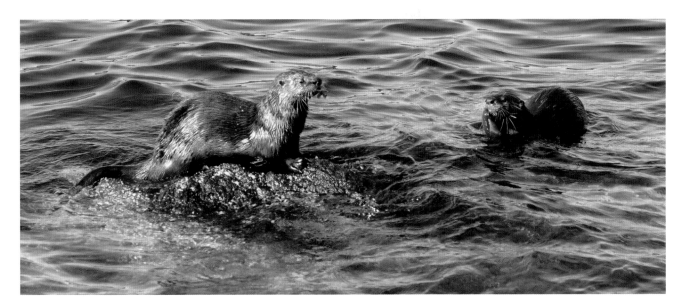

"So I chartered an Otter," remembered Jim Campbell, " . . . the big old, rough-engined float plane . . . I got them all on the plane, and instructed the pilot that he was to give them a good view of the islands as we flew over." They landed and travelled around. "The upshot of the tour," added Jim, "was that they really understood that the islands were each entitled to a different treatment. . . . They thought the Gulf Islands ought to be preserved."

The committee recommended the formation of the Islands Trust "to act in the best interests of the Islands and their residents, with due regard for the broader and province-wide interest." The trust was established in 1974 with a mandate "to preserve and protect."

## Parks and Reserves

When we first began to visit Pender in the 1980s, we got to know the late Allan Brooks, son and namesake of the pioneer bird artist and a keen naturalist himself. One day he took Andrea and I to explore the tide pools on a point on South Pender, and we saw for the first time a spectacular invertebrate, the gumboot chiton. A bald eagle perched in a nearby tree, low cliffs gave a grandstand view of distant Mount Baker and floats of kelp bobbed in the rough water. Allan explained that he and his wife owned three lots here and would love to see them become parkland. More than a decade later, I was delighted to be chair of the Pender Islands Conservancy Association when—through a generous donation from the Brooks family and fund raising by The Friends of Brooks Point—Brooks Point became a nature reserve.

The initial vision of the Islands Trust derived from Britain's National Trust, a private body responsible for managing a network of historic buildings and natural areas. Gradually that vision is evolving with the participation of many government bodies and other organizations.

Many parts of the islands are now protected in one way or another. In addition to marine parks (discussed elsewhere), the islands have 14 provincial parks, from Gabriola Sands south to Ruckle on Salt Spring. In 1971 the province created the first ecological reserves system in the world, and today nine reserves protect several vulnerable island groups as well as larger areas on Galiano and Salt Spring. The Capital Regional District also has a park system, and its island parks include Mount Parke Park on Mayne and park reserves at Pender's Brooks Point and Salt Spring's Mill Farm. Nanaimo Regional District manages Descanso Bay on Gabriola.

*The giant green anemone is an animal of tide pools and rocky shores.*

Some individual islands have established conservancy organizations, beginning with Galiano in 1989 and followed by Pender, Salt Spring, Mayne and Gabriola. These have focussed public and private funds on acquisition of numerous areas, while covenants with private landowners protect others. The Habitat Acquisition Trust and the Islands Trust Fund (the conservation arm of the Islands Trust) have worked closely with some of these organizations; the Islands Trust Fund lists more than 50 areas protected or covenanted within the Southern Gulf Islands.

A recent summary of protected land from all sources showed the most on Saturna (44 percent of land area), followed by South Pender (29 percent), North Pender (18.5 percent), Salt Spring (16 percent) and Galiano (14 percent).

### Lying Face Down

It looks a bit like the pinkish sole of a rubber boot and it clings to the rocks near the low tide zone, so it's not often seen. But it's worth looking at, since it is the world's largest chiton and can grow up to 33 centimetres (13 inches). When the tide is in, it crawls around eating seaweed and then returns to its favourite hollow. It harvests with a tongue covered with teeth that contain so much of the mineral magnetite that the animal will stick to a magnet. It will slowly curl up like an armadillo if something disturbs it. Chitons belong to a group of mollusks with multiple plates protecting the soft parts, but the gumboot hides its eight plates under its thick mantle. Also known as the great Pacific chiton, it was part of the traditional diet of the Haida, who gave it a picturesque name that means "lying face down forever."

*The gumboot chiton is found at lowest tides. Photo Bernhard P. Hanby*

## A Patchwork Park

Ever since the 1960s, the federal government has talked of its desire to establish a national park in each major natural region of the country.

The Georgia Basin is already heavily urbanized, and while the government was creating new national parks in remote areas of the country, the Gulf Islands were developing to such an extent that soon no large area of wild land would be available. Finally the federal and provincial governments decided to work together on assembling land in the Pacific Marine Heritage Legacy program, and out of that effort has come the Gulf Islands National Park Reserve, established in 2003.

As it stands, the park reserve extends over 35 square kilometres (13.5 square miles) of land and intertidal areas including parts of 15 large islands, and encompasses many smaller islets and 26 square kilometres (10 square miles) of marine areas. The biggest stretch of land

*Kayakers inshore in Ella Bay, North Pender.*

*The park at Brooks Point on South Pender is a favourite hangout for orca watchers.*

is on Saturna, followed by North and South Pender, Portland and Sidney Island. It incorporates a number of former provincial parks and marine parks as well as newly acquired lands, and the program continues to acquire new areas.

The park reserve has established a head office—and a campsite—in Sidney and has field staff based on Pender and Saturna. It offers programs in a number of sites and develops policies on management issues.

### Aboriginal Lands?

The Gulf Islands park reserve is not yet a park because there is still no First Nations treaty settlement for the Southern Gulf Islands. A number of First Nations have had traditional territories on the Gulf Islands, and a claim advanced by the Hul'qumi'num Treaty Group specifies core aboriginal title lands that include virtually all the land featured in this book. Parks Canada is currently discussing this with 19 nations and working to develop aboriginally owned and operated ecotourism businesses within the park.

### Marine Conservation

Protection by the Gulf Islands National Park Reserve extends 200 metres (656 feet) into the sea in waterfront areas. Parks Canada is also conducting a feasibility study for a proposed Southern Strait of Georgia National Marine Conservation Area Reserve, covering the waters from D'Arcy Island to the south shores of Salt Spring and Galiano. This could provide additional protection for invertebrates, fish, marine mammals and seabirds in the region, and could also benefit commercial fisheries by increasing productivity in one of the world's richest marine environments. It could also be the Canadian part of a wider Orca Pass International Stewardship Area, which organizations on both sides of the border jointly propose.

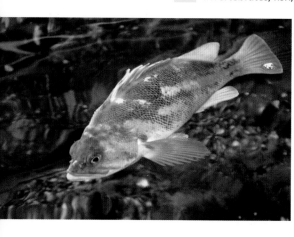

*Lurking in the reefs, copper rockfish are vulnerable to overfishing.*

## Saving the Islands

One day a fellow performer met Thetis musician David Essig in Toronto. "Geez," he said, "I was out in Vancouver last month and I saw this guy walking around downtown in a grey wool suit, and he looked just like you!" David explained that it was indeed him, for in addition to his musical career he has spent 13 years as an island trustee, and more than 10 years of that as chair of the Islands Trust. He stepped down from both positions in 2005.

Two years after he moved to Thetis in 1990, David was voted in as trustee. During his performing tours of Italy he had visited the island of Ischia near Naples. "It's the same size as Thetis," he explained. "It has a population of 30,000 people, it's all paved and it has no trees. I didn't want that to happen to Thetis."

"I became vice-chair of the trust in the year the Mac Blo case was settled," adds David, referring to the case in which—after a dispute on Galiano—the Court of Appeal confirmed the right of the trust to make planning bylaws.

When he became chair, David became responsible for leading planning and management programs for the 32,000 constituents of the 5,000 square kilometres (about 1,930 square miles) of islands and water trust area, which includes all the Southern Gulf Islands, as well as others around the Strait of Georgia, with a 36-person staff and a $3.5 million budget. "When I went in, the trust had a reputation as being a draconian enforcer of bylaws," explained David. "We needed to reinvent ourselves in a more positive proactive role." A cultural change shifted the trustees to being enablers rather than enforcers.

During David's period in office the trust has opened up dialogue with First Nations.

"Treaty negotiations involve senior governments," explained David. "We were able to negotiate a protocol agreement with one group, recognizing that we have much in common. We have been able to share geographical knowledge and have a common interest in preservation of important natural features."

The Islands Trust Fund, the conservation arm of the trust, was set up, along with legislation permitting tax relief for covenants on private land. Formerly unrestrained development of new subdivisions now has to relate to the island vision (community plan) and is subject to bylaws. "But each island has its own set," explained David. "We spent an incredible amount of time explaining inconsistencies."

The trust's powers do not meet everyone's expectations. "We can't control logging," said David. "The government retains management of this and other industrial developments, such as fish farms." Nor can the trust control population pressure, or the yuppification that happens as wealthy people buy up property. The trust "has to do the best job we can with the tools we've got."

*A fishing boat runs down Navy Channel between Pender (left) and Mayne.*

### New Society Publishers

New Society Publishers is not your typical publishing house. In four hectares (10 acres) of Gabriola forest, their offices are "surrounded by a pond, gardens and chicken yard—and way too may dogs!" The organization grew out of British Columbia's food co-op movement in the 1980s. In 1996 Judith and Christopher Plant formed a Canadian branch of a US-based publisher that first used the New Society name, then made a friendly takeover of the American company.

New Society does not publish typical books, either. Dedicated to facilitating social change, the list include such titles as *Change the World for Ten Bucks* and *Planet U: Sustaining the World, Reinventing the University*. Each book contains an eco-audit, and in 2005 New Society became the first North American publisher to become carbon neutral by tracking carbon emissions and contributing to programs to offset an equivalent amount. The Association of Book Publishers of British Columbia recognized New Society's leadership with the Jim Douglas Publisher of the Year Award in 2003.

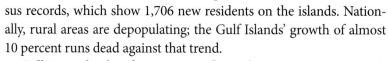

## Sustainable Islands? Slow Islands?

"The changes on Pender have been subtle," explained a skipper of the *Mayne Queen* in the early 1990s to journalist Don Hunter. "I remember when there were 150 people on the island and you knew every house and everybody who lived in them. The road was two tracks with grass down the middle and you counted cars for fun."

The changes are no longer subtle. As I write, Otter Bay Marina, near the Pender ferry terminal, is completing 32 time-share cabins, for which a quarter share costs more than a Magic Lake lot with a house did a few years ago. On the hill above Otter Bay Road, a newly cleared road through the forest will serve a new subdivision on the hilltop. "They must be suffering from some sort of madness," a South Pender Islander said to me in the ferry queue after driving through all the activity. The extent of development is clear from 2006 census records, which show 1,706 new residents on the islands. Nationally, rural areas are depopulating; the Gulf Islands' growth of almost 10 percent runs dead against that trend.

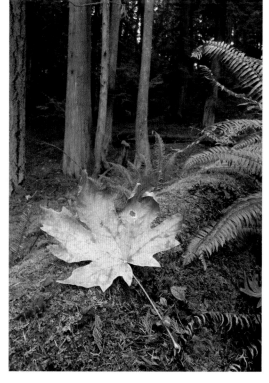

*The slow cycle of the seasons continues where nature is undisturbed.*

Full-time islanders face many conflicts of conservation and development, arising from their need to earn a living, their concern for social and environmental values, and their desire to provide a safe and supportive environment to all members of society. Full-time islanders are not the only stakeholders; many people live part-time in both the city and on an island, or spend long periods in both at different times of their lives. Many people recognize tourism as an essential component of island life both financially and philosophically; it is valuable to island economies and allows islanders to share the beauty of our landscape with the majority who cannot live here full-time.

Sustainable development is an emerging general principle sometimes defined as "positive socio-economic change that does not undermine the ecological and social systems upon which communities and society are dependent."

The Islands Trust, other public bodies, nonprofit and commercial organizations, and individuals engage in many initiatives to address the wider concerns. Island organizations support organic farming, heritage seed banks and apple co-operatives; sustainable forest management and restoration of damaged areas; cleaning up beaches, protecting riparian areas and restoring fisheries; and ecological education for children. These and many other efforts are essential, for if we do not succeed in managing our own growth, paradise found is in danger of becoming paradise lost. It is no wonder that Gulf Islands people talk of developing a "slow islands" movement. On rural West Coast islands," said Bowen Islander Kathy Dunster, "slow is not only possible, it is possibly the only solution."

English writer John Fowles reminds us, "Island communities are the original alternative communities. That is why so many mainlanders envy them . . . Some vision of Utopian belonging, of social blessedness, of an independence based on co-operation, haunts them all."

And indeed, beyond their local concerns, many islanders have a utopian vision and a high level of social, political and environmental concern. The Gulf Islands are a hotbed of alternative viewpoints. The other side of the "eccentric" label that Gulf Islanders earned in the past is an originality of thought and a reaching for creative solutions, not just for individuals and local problems but for society at large. As well as working for their local com-

munity, many islanders import and market fair-trade coffee from the Third World, advocate fairer voting systems, analyze the shortcomings of the industrial establishment in mainstream and alternative media, take suitcases full of books to a Mexican school and in many other ways work for peace, children, the world's poor and the environment on a national and international scale.

And perhaps we can see the islands as a workshop for testing new economic and social ideas, so that all this dedicated effort on the islands may produce methods that we can apply to the wider world, as sustainability moves—as it must—from being a new political buzzword to a way of life.

The islands have been—and are—many things to many people: a place to live, a resource to plunder, a playground free of the pressures of daily life or of society, a refuge from poverty and discrimination. To many they still resemble the enchanted isles longed for by the ancient Celts. But increasingly the islands have become a testing ground for ideas of sustainability and a workshop where we can develop and refine ecological and social ideas. John Fowles in *Islands* discusses another island image, that of Shakespeare's in *The Tempest*. He sees the island drama as "a parable about the human imagination: its powers, its hopes, its limits . . . "

Perhaps here is another image that Gulf Islanders can use, of a group of enchanted islands in which we can imagine a better future not just for islanders, but for the world.

*Looking west from the eastern tip of Saturna Island, a sunset backdrops BC's great inland sea.*

## Author's Note

It has been fun to travel again through the islands—into their past and present, their landscapes and nature, their culture and character. Once again I am impressed by their richness of landscape and wildlife, of culture, and of people, and regret that this book can offer only an overview, a taste, of that diversity. I hope this personal sample of stories and images that have entertained, interested or moved me will in turn move our readers, whether long-term residents or newest visitors, to go out and make their own new discoveries in the accessible islands.

In the extensive information about the islands in print, on the web and in people's memories there are many conflicting versions of stories. I have tried to be as precise as my many sources allowed. Sometimes though, I have had to choose what seemed the most likely or credible version of a story from several conflicting ones. Folklore is alive and well, and so, alas, is error.

## Photographer's Note

This is the first project of the sort that I have photographed with entirely digital equipment. Until only a few short years ago, it would not have been possible; the quality wasn't there. Living in an isolated area like the Gulf Islands has always been a challenge for photographers, since we faced numerous and time-consuming trips to Victoria or Vancouver to have our images processed. Shooting digitally has provided welcome relief from these trips. Now, though, we must be both photographers and image processors and have a good grasp of computer programs too. A reliance on new technology has many benefits, but I think I can say for many professional photographers that we do miss film and the darkroom. For most of us, those long nights in the darkroom are becoming a distant memory, just like the LPs and cassettes that we used to listen to while working.

I'm often asked what type of equipment I use and what my digital workflow entails. I shot most of the photographs in this book with a Nikon D2X, a versatile workhorse of a camera. At 12.4 megapixels, the D2X is capable of producing images that I think are far superior to any film. Some will argue this point, of course, and state that it's only different. I used lenses ranging from an extremely wide-angle 10 millimetres to a long telephoto of 300 millimetres and every focal length in between.

Projects like this are a huge undertaking for a photographer, not just in the sheer number of images produced—in this case approximately 25,000—but also in the image processing and cataloguing efforts. The images in this book were processed in Photoshop CS2 and catalogued using Extensis Portfolio. The actual process of shooting the photographs accounts for about 20 percent of the time I spent working on this project; the remaining 80 percent was spent in long hours in front of the computer, editing images, adding keywords, accurately captioning the images and making final selections for the book.

For additional information about the photographs, please visit my website at www. gulfislandsphotos.com/bookimages. Each photograph has detailed notes about locations, technical data and links to similar images and events that might interest you.

*Enchanted Isles* is the result of two years of travel through these spectacular islands. I met many wonderful people, spent many weekends at the endless festivals and explored beaches and trails on almost every island, some accessible only by private boat. I hope you enjoy this personal view of the incredibly beautiful Southern Gulf Islands.

# *Acknowledgments*

First thanks are due to the friends who introduced me to various islands, including Vic and Phyllis Fafard (Gabriola); Ed Andrusiak and Sher O'Hare, and Tom and Ann Hennessy (Galiano); Jennifer Iredale and John and Helen O'Brian (Mayne); Patrick and Angela Verriour (formerly of Pender), as well as the many interviewees for previous Gulf Islands books. Much background information has come from those who have recorded their memories and researches in manuscript, in print, and on the web, and the many islanders who have informally shared their knowledge and concerns with me over the years on the ferries, in coffee shops, at docks and on beaches.

For this book, volunteers and staff in tourist offices, island libraries and bookshops, and Islands Trust, Gulf Islands National Park and other public agencies have been universally helpful.

Particular thanks are expressed to those who have been interviewed, or who have shared, obtained or reviewed specific pieces of information. These include Gerry and Kathy Bennett (Powell River); Lisa Dunn (Islands Trust); Phyllis and Ted Reeve, Jordan Sorrenti and Sue DeCarteret (Gabriola); Marcia DeVique (Galiano); Frank Ducote, Susan Taylor, Sharon Jinkerson and David J. Spalding (Pender); Jim Campbell and John Wiznuk (Saturna); and David Essig (Thetis). None of my informants have any responsibility for any errors I may have made nor do they necessarily share my opinions.

—David Spalding

Many people assisted in my quest for images of the Southern Gulf Islands. Thanks to Ian Gidney and his staff at Sidney Marine Safari Ltd. for helping me in my pursuit of orca photographs, Bob Reimer at Coast Helicopter College for his excellent skills as a pilot, Richard Lamy at Parks Canada, Lisa Baxter at Saturna Island Vineyards and all the folks who allowed me to photograph them while they went about their pleasure and business. Thanks, especially, to the many friends who accompanied me on trips and contributed companionship, laughter and great food, and often served as subjects for the photos.

—Kevin Oke

We would both like to thank our wives, Andrea Spalding and Cherie Oke, who have provided, as always, encouragement, information, stimulus, and support.

For turning this compilation of pictures and words into a beautiful book, we thank expert and enthusiastic editor Susan Mayse, masterful designer Roger Handling, as well as Silas White, Vici Johnstone, Anna Comfort, and everyone else at Harbour.

# SELECTED FURTHER READING

## Southwestern British Columbia

Arnett, Chris. 1999. *The Terror of the Coast: Land Alienation and Colonial War on Vancouver Island and the Gulf Islands, 1849–1863*. Vancouver, Talonbooks.

Butler, Robert W. 1997. *The Great Blue Heron*. Vancouver, UBC Press.

Lillard, Charles, with Terry Glavin. 1998. *A Voice Great within Us: The Story of Chinook*. Vancouver, New Star Books. Transmontanus 7.

Spalding, David A.E. 1998. *Whales of the West Coast*. Madeira Park, BC, Harbour Publishing.

Vermeer, Kees, and Robert W. Butler. 1989. *The Ecology and Status of Marine and Shoreline Birds in the Strait of Georgia, British Columbia*. Ottawa, Canadian Wildlife Service, special publication.

Walbran, John T. 1971. *British Columbia Coast Names: Their Origin and History*. Vancouver, Douglas & McIntyre.

Yates, Steve. 1988. *Marine Wildlife of Puget Sound, the San Juans, and the Strait of Georgia*. Guilford, CT, Globe Pequot.

## Southern Gulf Islands

Barman, Jean. 2004. *Maria Mahoi of the Islands*. Vancouver, New Star Books, Transmontanus 13.

Barman, Jean. 2004. *The Remarkable Adventures of Portuguese Joe Silvey*. Madeira Park, BC, Harbour Publishing.

Brazier, Graham, and Nick Doe, eds. 2005. *Proceedings of the Islands of British Columbia Conference: An Interdisciplinary Exploration: Denman 2004*. Denman Island, Arts Denman.

Elliott, Dave. Sr., and Janet Poth. 1990. *Saltwater People*. Saanich, School District 63 (Saanich).

Elliott, Marie. 1984. *Mayne Island & the Outer Gulf Islands: A History*. Mayne Island, Gulf Islands Press.

Freeman, B.J. Spalding, ed. 1961. *A Gulf Islands Patchwork*. Sidney, BC, British Columbia Historical Federation, Gulf Islands Branch.

Harker, Douglas, ed. 1993. *More Tales from the Outer Gulf Islands: An Anthology of Memories and Anecdotes*. Pender Island, British Columbia Historical Federation, Gulf Islands Branch.

Harrington, Sheila, and Judi Stevenson, eds. 2005. *Islands in the Salish Sea: A Community Atlas*. Surrey, BC, Touchwood Editions.

Kahn, Charles. 2004 (revised). *Hiking the Gulf Islands*. Madeira Park, BC, Harbour Publishing.

Murray, Peter. 1991. *Homesteads and Snug Harbours: The Gulf Islands*. Victoria, Horsdal & Schubart.

Ovanin, Thomas K. 1984. *Island Heritage Buildings*. Victoria, Islands Trust.

Porter, Cy. 2004. *Between the Isles: Life in the Canadian Gulf Islands*. Victoria, Trafford Publishing.

Reimer, Derek. 1976. *The Gulf Islanders*. Victoria, Sound Heritage, Vol. V, No. 4.

Repard, Dora, co-ord. 2005. *Gulf Islands Ecosystem Community Atlas*. Vancouver, Canadian Parks and Wilderness Society, BC Chapter.

Spalding, David and Andrea Spalding, Georgina Montgomery and Lawrence Pitt. 2000. *Southern Gulf Islands*. Canmore, AB, Altitude Publishing. (2nd ed.).

Sweet, Arthur Fielding et al. 1988. *Islands in Trust*. Lantzville, Oolichan Books.

## Galiano Island

Steward, Elizabeth. 1994. *Galiano Houses and People—Looking Back to 1930*. Galiano Island, by the author.

## Mayne Island

Borradaile, John. n.d. *"Lady of Culzean": Mayne Island*. Mayne Island, by the author.

**Saturna Island**

Murray, Peter. 1994. *Home from the Hill: Three Gentlemen Adventurers*. Victoria, Horsdal & Schubart.

Schermbrucker, Bill. 2005. *The Campbells of Saturna*. Saturna Island, BC, Saturna Community Club.

**Pender Island**

Elliott, Marie, ed. 1994. *Winifred Grey: A Gentlewoman's Remembrances of Life in England and the Gulf Islands of British Columbia*. Mayne Island, Gulf Islands Press.

Fox, Richard. 2006. *The Pender Islands Handbook*. Victoria and North Carolina, by the author.

**Inner Islands**

Bond, Bea. 1991. *Looking Back on James Island*. Victoria, Porthole Press, Ltd.

Sidwell, Walter. n.d. *The Island I Can't Forget*. Deroche, BC, by the author.

Skolrood, A. Harold. *Piers Island: A Brief History of the Island and Its People, 1886–1993*. Lethbridge, AB, by the author.

Yorath, Chris. 2000. *A Measure of Value: The Story of the D'Arcy Island Leper Colony*. Surrey, BC, Touchwood Editions.

**Salt Spring Island** (older historical references listed in Charles Kahn bibliography)

Akerman, Bob, and Linda Sherwood. 2005. *The Akerman Family: Growing Up with Salt Spring Island*. Salt Spring Island, by the author.

Conover, David. 1972. *One Man's Island*. Markham, ON, Paperjacks.

Garner, Joe. 1980. *Never Fly Over an Eagle's Nest*. Lantzville, BC, Oolichan Books.

Kahn, Charles. 1998. *Salt Spring: The Story of an Island*. Madeira Park, BC, Harbour Publishing.

Scott, Victoria, and Ernest Jones. 1991. *Sylvia Stark: A Pioneer*. Greensboro, NC, Open Hand Publishing Inc.

**Middle Islands**

Kelsey, Sheila. 1993. *The Lives behind the Headstones*. Duncan, BC, Green Gecko Electronic Publishing.

Oliphant, John. 1991. *Brother Twelve*. Toronto, McClelland & Stewart.

**Gabriola and Newcastle Islands**

Bentley, Mary and Ted Bentley. 1998. *Gabriola: Petroglyph Island*. Victoria, BC, Sono Nis Press.

*Shale*. Various dates. Gabriola Island, Journal of the Gabriola Historical and Museum Society.

Merilees, Bill. 1998. *Newcastle Island: A Place of Discovery*. Surrey, BC, Heritage House.

**Fiction for Adults Set on the Gulf Islands**

Deverell, William. 1997. *Trial of Passion*. Toronto, Seal Books.

Grayson, Steven. 2004. *Rain and Suffering: The Real Gulf Islands Guide*. Salt Spring Island, Starling Press.

Howarth, Jean. 1988. *Tales from Madronna: Island Time*. Toronto, Summerhill Press.

Richardson, Bill. 1993. *Bachelor Brothers Bed & Breakfast*. Vancouver, Douglas & McIntyre.

Rule, Jane. 1989. *After the Fire*. London, Pandora.

**Fiction for Children Set on the Gulf Islands**

Gaetz, Dale Campbell. 1994. *A Sea Lion Called Salena*. Vancouver, Pacific Educational Press.

Olsen, Sylvia, Rita Morris and Ann Sam. 2001. *No Time to Say Goodbye: Children's Stories of Kuper Island Residential School*. Victoria, Sono Nis Press.

Spalding, Andrea. Illustrations by Janet Wilson. 2002. *Solomon's Tree*. Victoria, Orca Book Publishers.

Woodson, Marion. 1994. *The Amazon Influence*. Victoria, Orca Book Publishers.

# INDEX

Harbour Publishing Co. Ltd.
P.O. Box 219
Madeira Park, BC
V0N 2H0
www.harbourpublishing.com

Printed and bound in China
Text design by Roger Handling

Harbour Publishing acknowledges financial support from the Government of Canada
through the Book Publishing Industry Development Program and the Canada Council for
the Arts, and from the Province of British Columbia through the British Columbia Arts
Council and the Book Publisher's Tax Credit through the Ministry of Provincial Revenue.

THE CANADA COUNCIL | LE CONSEIL DES ARTS
FOR THE ARTS | DU CANADA
SINCE 1957 | DEPUIS 1957

BRITISH
COLUMBIA
ARTS COUNCIL
Supported by the Province of British Columbia

**Library and Archives Canada Cataloguing in Publication**

Spalding, David A. E., 1937-
    Enchanted isles : the southern Gulf Islands / David A.E.
Spalding ; photography by Kevin Oke.

Includes index.

ISBN 978-1-55017-422-9

    1. Gulf Islands (B.C.)—History.  2. Gulf Islands (B.C.)—Pictorial
works.  I. Oke, Kevin, 1958-  II. Title.

FC3845.G8S63 2007          971.1'28          C2007-904473-5